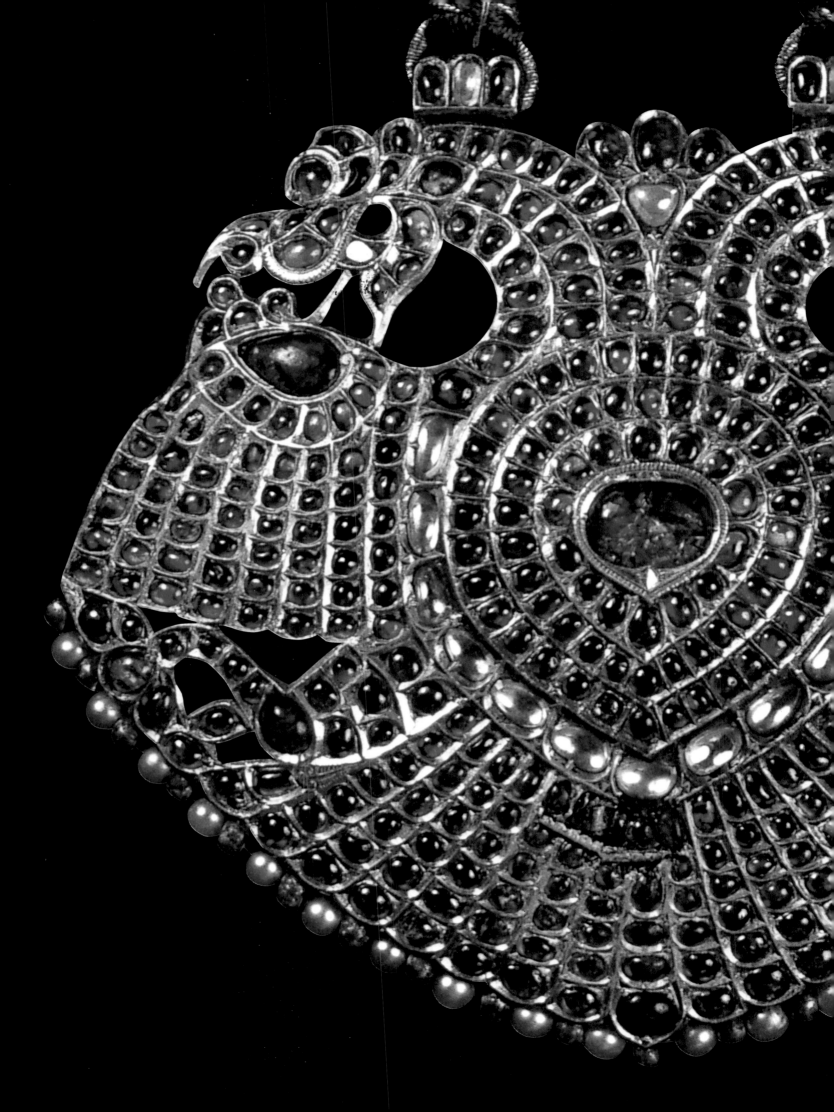

Indian Jewellery

M. L. Nigam

Photographs
Dheeraj Paul

Lustre Press
·
Roli Books

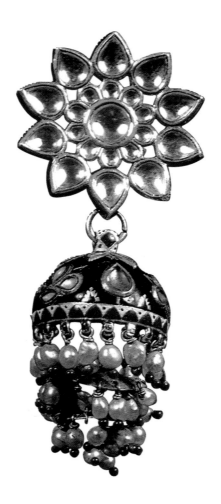

ISBN : 81-7436-067-0

Reprinted 2001

© **Roli Books Pvt. Ltd. 1999**
 Lustre Press Pvt. Ltd.
M 75 G K II Market, New Delhi 110 048, India
Tel: (011) 6442271, 6462782, Fax: (011) 6467185

Text : M. L. Nigam
Concept and Design : Ranmal Singh Jhala
Produced at Roli CAD Centre

Photocredits:
Author: Pages 52 (above), 74
Avinash Pasricha: Back Cover
Dheeraj Paul: Pages 8, 9, 10, 11, 13, 14, 15, 16, 17, 19,
20 (above & below, left), 21, 25, 26, 27, 28, 29, 31 (left),
32, 33, 34 (left), 36, 37, 38 (below), 40 (below), 41, 43,
44, 46, 49 (above), 52 (below), 53 (below), 60 (above),
63, 64, 68, 70 (middle & below), 75, 76, 77, 78, 79, 80,
81, 82, 83, 84, 86 (above), 87, 91 (below), 94, 95
National Museum: Front cover, pages 2-3, 5, 6, 30, 31
(right), 34 (right), 35, 38 (above), 39, 40 (above), 42, 47,
48, 49 (below), 50, 51, 53 (above), 54-55, 56, 57, 58-59,
60 (below) 61, 62, 66, 85, 86 (below), 89, 90, 91 (above,
left), 92-93
Roli Books: Pages 4, 20 (below, right), 22, 23, 24, 39
(above), 69, 70 (above), 91 (above, right)

Printed and bound at
Star Standard Industries Pte. Ltd.
Singapore

Author's Acknowledgement
I gratefully acknowledge the courtesy of the authorities
of the National Museum, New Delhi; the Salar Jung
Museum, Hyderabad; the Government State Museum,
Hyderabad; the Government Museum, Chennai and the
Bharat Kala Bhavan, Varanasi, for granting permission to
take photographs and allowing them to be included in
the book to highlight the text. I must also thank Dr.
I.K. Sharma, Director, Salar Jung Museum; Dr. Krishna
Sastry, Director, Archaeology and Museum, Govt of
Andhra Pradesh; Prof. R.C. Sharma, Director, Bharat
Kala Bhavan, Varanasi and Shri. N. Devasahayam,
Government Museum, Chennai, for their active help and
cooperation. I would like to end by mentioning my
special thanks and gratitude to Mrs. Rita Devi Sharma,
Keeper of the National Museum, New Delhi.

Previous pages 2 and 3: **Pendant.** *A gold
pendant in fine 'kundan' (inlay) work in the
shape of a mythical bird with one body and
two heads; set with rubies, diamonds and
emeralds.*
Early eighteenth century AD. South India.
National Museum, New Delhi, 57.1053.

Contents

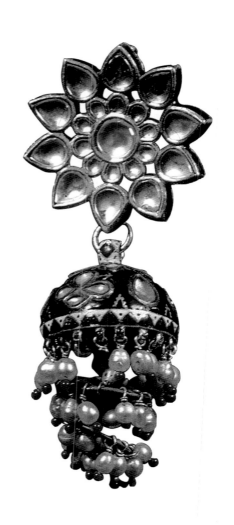

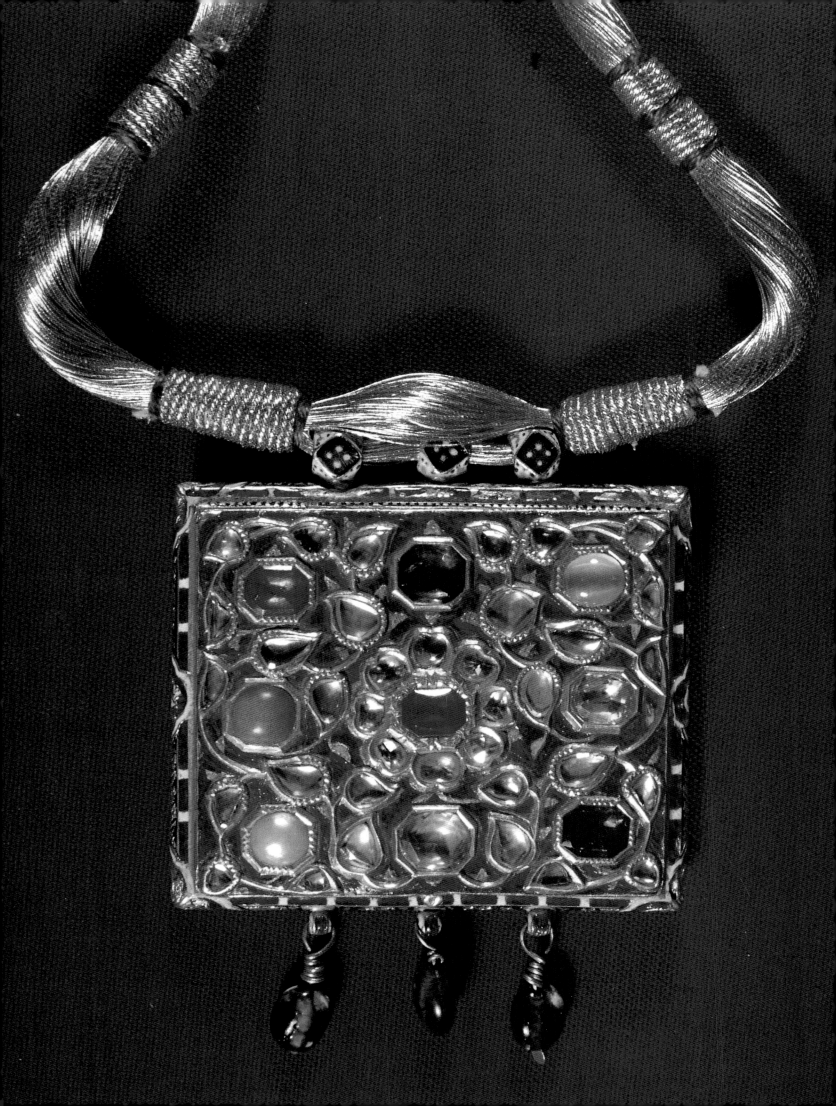

Indian Jewellery

From the pantheon of Hindu deities, nine of them are believed to relate to five planets (Mercury, Venus, Saturn, Mars and Jupiter), the sun, the moon, the ascending phase (Rahu or the dragon's head) and the descending phase (Ketu or the dragon's tail) of the moon. This particular configuration of the Hindu cosmology is intimately related to gems used in Indian jewellery. Since time immemorial, gem stones have been used for medicinal and therapeutic purposes. Combined in a certain arrangement, the nine gems used in a piece of jewellery is called the 'navaratan' (nine gems). It captures in microcosm the spatial relationship of the heavenly bodies of the cosmos and harnesses their augmented power in the service of humankind. These nine gem stones later divided into five greater gems (diamond, pearl, ruby, sapphire and emerald) and four lesser gems (topaz, cat's eye, coral and hyacinth/zircon). Each of these gems draw energy in the form of cosmic rays from the heavenly body associated with it. The grouping of the nine stones in a set manner in a piece of jewellery is believed to be a storehouse of energy or power that is unending and enhances the life of the person wearing it.

Love for beauty is inherent in all human beings. It is this aesthetic impulse which prompts an individual to create, possess and enjoy all that is beautiful. Jewellery is, no doubt, an aid to personal beauty and this is probably the reason why the art of jewellery has been associated with the development of human civilisation. Even in the pastoral society of ancient India, jewels along with large herds of cows, stables of horses and elephants, were considered the four principal treasures. Hence, possession of costly jewellery and their lavish use on festive and other ceremonial occasions in India has been associated with rank and status in society.

There are other reasons too for the boost given to the craft of jewellery in ancient India. The supposed medicinal qualities of various precious stones and metals were found to be conducive to human health. Similarly, the common astrological belief in India that every planet has its own gem and that the wearing of that gem would pacify that particular planet probably further encouraged the use of gems and jewellery amongst the opulent of Indian society. Thus the wearing of *nava ratna* (nine gems): diamond (*hira*), ruby (*manikya*), cat's eye (*vaiduryam*), pearl (*mukta*), zircon (*gomedha*), coral (*munga*), emerald (*marakatam*), topaz (*pukhraja*) and sapphire (*nilam*), attained astrological sanction.

The possession of gems and jewellery in ancient India was also considered a kind of insurance against poverty and other natural mishaps in one's life. The malleable quality of the precious metals, like gold and silver, however proved to be detrimental to the continuity of some of the older forms of Indian jewellery. The frequent melting of old ornaments compounded this problem and led to a great cultural loss. Today, it is difficult to get good specimens of old Indian jewellery except in the temples of southern India, where the best examples of south Indian jewellery can still be seen.

Indus Valley Civilisation

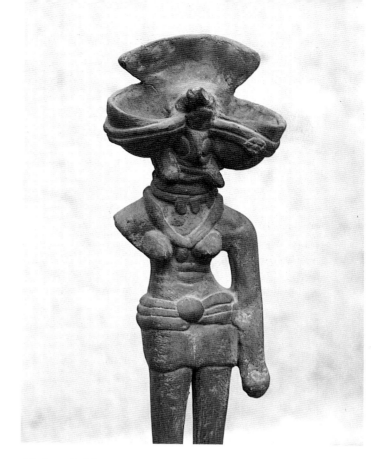

Mother Goddess. Terracotta.
2700-2000 BC. Mohenjodaro.
National Museum, New Delhi, 3506/260.

The famous figurine of a dancing girl from Mohenjodaro suggests the use of various ornaments such as necklaces, armlets, wristlets and bangles during the Indus Valley civilisation.

The archaeological excavations at Harappa and Mohenjodaro have yielded a large variety of beads of numerous shapes and materials. The strung beads were worn as armlets, bracelets, necklaces and girdles during the Indus Valley period. Beads of the precious metals, like gold and silver, must have been used only by the very rich, as they were relatively scarce.

Where did all this raw material come from? The precious metals, like gold and silver, were probably obtained from such distant places as Afghanistan. Copper must have come from Khetri in Rajasthan; hematite, for the red paste, from the islands in the Persian Gulf near Hormuz; steatite, jasper and bloodstone from Rajasthan; amethyst and green felspar from Hirapur north of Ahmedabad and jade from Eastern Turkistan; shell, agate, carnelian, onyx, chalcedony and rock crystal probably came from Kathiawar in Gujarat. Lapis lazuli came all the way from Badakshan and Afghanistan and turquoise from Khorasan.

Three delicate needles and hairpins of gold dated to this period testify to the high level of craftsmanship of the goldsmiths of the Indus Valley. They were adept in covering copper with thin pieces of gold, and gilding copper with gold. The craftsmen probably filled depressions in ornaments with stones, faence, shell or colour to produce the effect of enamelling— although they did not practise real enamelling. They have, however, left pieces of inlay which compare favourably with enamelled pieces found in Egypt and Mesopotamia. The heart shaped pendant found in Harappa is inlaid with faence and the pendant in the form of a lotus is alternatively inlaid with pieces of lapis lazuli and red stone.

The knowledge of manufacturing articles of copper was almost modern. The techniques employed by the coppersmiths of the Indus Valley included casting, forging, chasing, cutting and finishing. Casting both by the cire-perdue method and in ordinary unburnt clay moulds seems to have been practised.

It is no less amazing to note the diversity of techniques used in producing beads in ancient India. They are fashioned in cylindrical, globular, tubular, rectangular, oval and semi-circular forms. Apart from the science of metallurgy, the people of Harappa and Mohenjodaro possessed a good knowledge of the use of various hard stones. It is somewhat difficult to hazard a conjecture about the tools and techniques employed to manufacture beads of such semi-precious stones as quartz, jadeite and so on, which are harder than steel. They probably practised the method of rubbing and abrading the stones with pieces of harder stones to bring them to the required form. Similarly, they might have used drills and borers of quartz and other harder stones to carve out holes in softer beads. At Harappa, a special type of bead was made by cementing two or more stones together. The steatite beads were sometimes given a special treatment of heating to whiten the surface. Such beads are termed burnt steatite beads. There are painted steatite beads also; the fast colours were produced by applying mineral solutions on the beads and thereafter heating them under high temperatures. The beads were also glazed and polished to present a glossy surface.

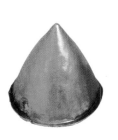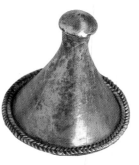

Head ornaments. *Made of conical gold sheets.*
2500 BC. Mohenjodaro.
National Museum, New Delhi, 49.254. (left) and
49.244/10 (right).

Head Ornaments : Several cone-like ornaments have been found in Harappa—a cone of gold (with a silver loop inside near the top, evidently to fasten the ornament on the head), a cone of silver inlaid with a circular piece of shell and others of faence, pottery, shell and steatite.

Several hairpins and hairpin beads, one of them of bronze, have been found in Harappa. Several fan shaped ornaments have also been recovered from Mohenjodaro. They are made of faence and probably represent the outspread tail of a dancing peacock. Some of the male terracotta figures from Mohenjodaro also seem to be wearing an ornament shaped like a horn.

Ear Ornaments : Several ear ornaments have been found in Harappa and Mohenjodaro which can be divided into different groups; ear-tops, ear-studs, ear-drops, ear-rings and ear-pendants.

Necklaces : People wore three ornaments on the neck—a choker, one necklace descending down to the collar bone and the third one covering the breasts. All these ornaments were made of strips of metals and beads.

Most of the necklaces recovered from the Indus Valley are made of beads. From Harappa, a necklace with thirteen pendants composed of several beads strung together on a copper wire, four long-faceted beads of gold, two cylindrical gold beads and discs of gold were retrieved. Apart from this, a necklace of two hundred and forty round gold beads was also found; an astonishingly large number and variety of beads—made of gold, silver and copper—have been dug up during excavations at Harappa.

A number of pendants were also found in Harappa; a beautiful heart shaped bead made of gold, a crescent shaped agate pendant, and a lotus shaped pendant which has eight petals, inlaid with lapis lazuli and red stones alternatively. The lapis lazuli inlay is marvellously still intact.

In Mohenjodaro beads made of jade, jasper, agate, carnelian, chalcedony and gold have been found. Unlike Harappa, where a copper wire was used to string the beads, here a thick gold one was used.

Bangles and Bracelets : Bangles of metal, shell and terracotta were commonly used. Men used a band with a disc to cover their arms. The clay bangles excavated from Harappa are well-polished and coloured. At Mohenjodaro, metal bangles seemed to have been favoured. Gold bangles with a thin sheet of gold wrapped over a core of shellac were prepared as hollow tubes and then bent. Silver, copper and bronze bangles have also been found at Mohenjodaro which are generally round or oval in shape.

Finger-rings : Finger-rings made of copper or bronze wire, round in section, have been found in Mohenjodaro. There are also rings with several coils, ranging from two to seven, of copper wire.

Girdles : Several types of girdles are seen on the terracotta figurines of Harappa. On another figure, that of a bearded man, a girdle composed of conical round disc beads has been noticed. At Mohenjodaro, busts are shown wearing girdles, but they seem more elaborate than those from Harappa.

Anklets : As most of the terracotta figurines from Harappa and Mohenjodaro have not survived intact, it is difficult to guess the types of foot ornaments. However, a few skeletons with anklets of paste beads have been found in Harappa.

Necklace. *With banded agates, steatite and gold beads.*
2500 BC. Harappa.
National Museum, New Delhi, 49.254/3.

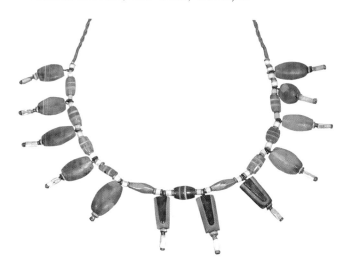

The Mauryan Period

It was during the rule of the Mauryas that India was, for the first time, brought under one political power. It added not only to the political stability of the country but also increased resources, encouraged economic growth and the all round prosperity of the people. The general opulence of the people is quite obvious from the glowing accounts left by the foreign writers who came to India in this era. Megasthenes and Nearchus, Greek travellers to Mauryan India, speak eloquently about the amount of jewellery the Indians wore and, indeed, how fond Indians were of ornate jewels.

In fact they had ornaments made of silver, gold, pearls, carnelians, lapis lazuli and other precious stones, to be worn on every part of the body. So much so that the *Jatakas* (Buddhist fables) which mention eighteen important handicrafts, included the working of precious stones and jewellery in that list.

The art of making jewellery had reached the heights of perfection during the Mauryan period. Much of this was because of the abounding resources and the brisk national and international trade of the extensive empire—which resulted in great development in the art. The raw material was procured by the state, handed over to skilled artisans appointed by the state and a strict vigil was maintained to avoid any theft.

Kautilya's *Arthasastra*, a treatise on statecraft composed during the rule of Chandragupta Maurya, the founder ruler of the dynasty, provides a graphic description of the art of jewellery making of that period. Even the minutest details at every stage, from the examination and procurement of raw materials to the last finishing touches given to ornaments, are clearly mentioned by the author. Any attempt to cheat by the goldsmiths was considered a serious offence and carried a severe penalty with it.

Jewellery was made of both precious and semi-precious stones. Mines producing precious stones like diamonds, rubies, emeralds and precious metals like gold, silver, copper and iron were controlled by the Director of Mines and Metals. More often than not, the director was an expert and fully conversant with the science of

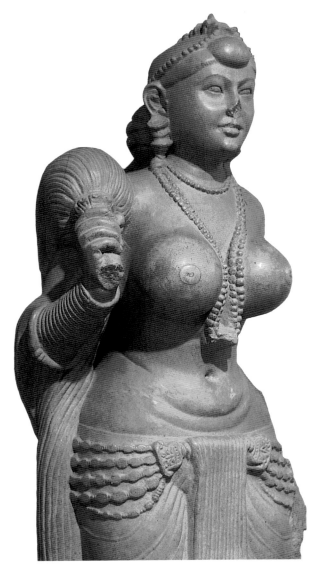

Didarganj Yakshi or fertility goddess. Sandstone. Maurya Period, third century AD. Patna, Bihar. Patna Museum, Bihar, 134.

metallurgy, the art of smelting and gemmology. He was assisted in his work by a team of experts appointed by the state. The state department, headed by a Superintendent, appointed skilled and trustworthy goldsmiths. The workshop they worked in was a closely guarded secret.

The names of a number of places, like mountains and rivers, which yielded gold and silver are mentioned in the *Arthasastra*; however, a majority of these places cannot be reliably identified. The gold and silver were received and given in weights. A number of names of weights and measures, such as the *suvarna*, *mashakas*, *kakani* and so on have come down to us.

Pearl Jewellery : Jewellery made of pearls seems to have been very popular in this period. They were strung together in cotton or metal and worn as

necklaces, bracelets, wristlets, girdles and anklets. The names of the necklaces were given according to the number of pearls strung onto them. For example, one thousand and eight pearl strings made the *indracchanda* necklace and one comprising half that number was known as *vijyacchanda*. Necklaces composed of sixty-four pearl strings were called the *ardha-hara*, those with fifty-four pearl strings were the *rasami-kalapa*, and so on. These forms in pearl jewellery probably continued well into the Gupta age.

Apart from types, various designs were also created by stringing together different varieties of pearls in a necklace. For instance, a *sirsaka* was a pearl necklace with one big pearl in the centre and two small pearls on either side. An *avaghataka* necklace had a big pearl in the centre with others gradually decreasing in size on both sides. *Ekavali* was a pearl necklace of a single strip and an *ekavali* with another gem in the centre was known as *yashti*.

The Sunga Period

Although there is not much archaeological evidence available, it can be safely inferred that the traditions of Mauryan jewellery must have continued on to the Sunga period. The Buddhist monuments at Bharut (Madhya Pradesh), Sanchi (Madhya Pradesh), Bodhgaya (Bihar) and Amravati (Andhra Pradesh), which are attributed to the Sunga and Satavahana phase of Indian history, provide an interesting aside on Indian jewellery through their intricately carved stone sculptures; firstly the forms of jewellery seem to have continued down the ages with little or no change and secondly, various ornaments worn by the male and female figures at Bharut throw light on what was actually worn by the people in that era.

A careful scrutiny of the Sunga and Satavahana art reveals that a large variety of ornaments to be used on the head, ears, neck, arms, waist and feet had come in vogue. The forms, motifs and designs of ornaments were drawn either from nature or sectarian symbols. For example, the ear-rings are very often shaped like the petals of a full-blown lotus. Numerous animal motifs, such as the snout of a crocodile, the head of a lion and the coil of a serpent adorn the ornaments of the Satavahana period. At Bharut, the famous Buddhist symbol *Triratna* (three gems) is very often found depicted in the jewellery of the male and female figures.

Men probably used an embroidered sash or *pataka*, at the waist. Forehead ornaments, long necklaces, girdles and anklets were worn, for the most part, by women.

Forehead Ornaments : Most of the female sculptures of Bharut are depicted as wearing a star-shaped ornament at the parting of the hair, on the top of the forehead. Another gem which also adorns their foreheads is the *chudamani* or the *makarika* (crocodile gem).

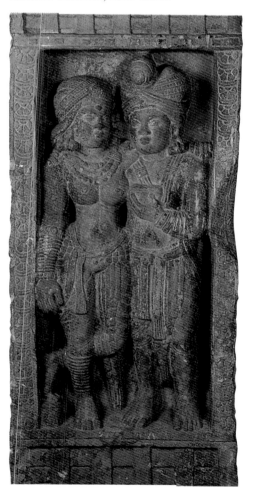

Amorous couple with typical Sunga headgear, ear-rings, pendant, girdle and heavy anklets on the feet. The head ornaments are adorned with pearls, the necklace is multi-stringed, possibly with filigree work, the girdle is studded with beads and the bangles are possibly of ivory. Stone. Sunga period, second century BC. Amin, Haryana. National Museum, New Delhi.

Ear Ornaments : Ear-rings were used by both men and women. A special ear-ring is seen at Bharut which is shaped like two spiral tubes that end with a four petalled flower. The crescent shaped *kundalas* (danglers), which find mention in the *Jatakas*, are found represented in Amravati sculptures—actual specimens have also been excavated in Taxila.

Necklaces : Necklaces made of gold, beads, pearls and other precious stones, seem to have been the most popular ornament amongst men and women in ancient India. In fact, Kautilya in his *Arthasastra* has mentioned a large variety of them. They were generally composed of numerous strings, popularly known as *yashti*, and the centre was adorned with a large gem called *nayakamani*.

The necklaces used to be both short and long—shorter necklaces were known as *kanthi* or *kantha*, a name still used popularly in the Indian vernacular. They were probably made of gold beads, pearls and precious gems. If the central gem of the necklace was a large pearl, it was called *sirshak*. A necklace composed of alternating pearls and gold beads was termed *apavartika*. *Ratnavali* was a necklace composed of a variety of gems, pearls and gold beads. A popular necklace was one comprised of gold coins named *nishka*, which was also the name of a gold coin. Another notable variety of the necklace used in the Maurya and Sunga periods is the *phalakahara* which comprised of three or five gems in a slab-like rectangular shape, set at regular intervals with pearls and consisting of numerous strings.

Bangles and Bracelets : The armlets or bracelets were commonly worn by men and women of the Sunga period. They seem to have been made of gold and encrusted with precious gems. The bracelets were known as *valayas*. According to the treatise *Gathasaptasati*, it was considered auspicious for married women to wear *valayas*.

Bracelets seem to have been named after the material employed to make them and, sometimes, even after the workmanship. For example the *ratnavalayas* were the bracelets set with precious stones, while the *sankhavalayas* were made of conch (*shankha*) and the *jalavalaya* were bracelets with perforated workmanship. Bracelets made of ivory were also in vogue.

Armlets were also known as *valayas* due to their ring-like shape. Various shapes, based on the creeper and *makara* motifs, of the armlet are mentioned in ancient Sanskrit literature.

Girdles : There are numerous references to girdles worn by women in early Sanskrit and Pali literature. Their names seem to have been based on the number of strands in the ornament or the sound they produced when the wearer moved. The names such as *mekhala*, *kanchi*, *saptaki*, *rasana* and *sarasana*, are said to have signified the number of strands composing the girdle. For instance, the term *saptaki* denotes a girdle with seven strings. *Rasana* was probably a girdle that had small bells. Some other types of girdles were *maddavina*, *kalabuka*, *muraj* and *deddubhaka*. The *maddavina* had a rich, jewelled border. The *kalabuka* was composed of many strips plaited together, the *muraj* had drum shaped knobs and the *deddubhaka* had knobs in the form of a water snake.

Initially, the girdles seem to have been composed of beads, including gold and silver. They were followed by chains of gold and silver with little bells and were commonly used by the courtesans. Eventually it assumed an elaborate and expensive form of five, six or seven strings of gold beads.

Anklets : Anklets were popularly worn by the women of the Sunga and Satavahana periods. The most common variety appears to be formed of spiral coils, piled on top of each other. Various names such as *manjira tulakoti*, *nupura*, *padangada*, *hamsaka* and *palipada* in Sanskrit and Pali languages would suggest a large variety of anklets in ancient India. Sometimes they were embedded with small bells, *kinkinis*, to produce a jingling sound as the person walked.

With the increase in resources and trade, the Mauryan empire forged intimate relations with West Asian monarchs. This alliance, especially with the Greeks and Romans, introduced their traits and traditions into Indian jewellery. Some of the ancient jewellery found in Taxila would suggest such a cultural blending.

Graeco-Roman Jewellery at Taxila

Finger-ring. *With filigree work and vine scroll edged with a beaded border.*
First century AD. Taxila.
National Museum, New Delhi, 49.262/37.

Taxila, and its adjoining townships of Sirkap and Sirsukh, played a dominant role in shaping the political and socio-religious history of the northwest frontiers of India from 500 BC to 500 AD. The city was time and again destroyed, and then rebuilt, by the invaders, like the Greeks, the Mauryas of Magadha, the Bactrian Greeks, the Sakas, the Parthians, the Kushanas and finally the Huns at the close of the fifth century AD.

The first habitation here was founded by Alexander the Great, in the course of his conquests, at Bhir Mound. It was during the second century BC that another township Sirkap (which was laid in chessboard fashion, a typical Hellenistic pattern) was made the prominent cultural centre by the Sakas and the Parthians. Later, in the first century AD, the Kushanas shifted the city from Sirkap to Sirsukh.

The excavations at Bhir Mound, Sirkap and other sites like Dharamarajika, Jaulian and Giri have brought to light a very rich and highly evolved culture which is a fine blend of the Greek, Indian, Graeco-Roman and Persian norms and traditions. A total of two hundred and thirteen ornaments were excavated—almost all made of gold.

Barring a few exceptions, the jewellery is distinctively Greek or Graeco-Roman in style and form. Amongst the exceptions is a silver necklace which is typically Indian and dateable to the Mauryan period. Similarly, a few anklets recovered from Sirkap are characteristically Maurya-Sunga. Then there are the heavily incrusted bracelets which have been attributed to Scythic and Sarmatian workmanship.

The jewellery recovered from Sirkap has been dated to the first century BC. There are two basic reasons for it being identified as Graeco-Roman. Stylistically, the jewellery found in Sirkap is different from the ornaments found represented in the sculptures at Sanchi and Bharut exhibiting Indian styles. Secondly, the jewellery from Sirkap reveals the use of technical processes then unknown in India, but identical to those employed throughout the Greek and Graeco-Roman world.

It appears that a gold coin of Queen Faustina (141 AD) tied as a central pendant in between two tortoise shaped gold beads in a necklace was much in demand.

It might be interesting here to reveal a bit of the historical factors which led to the appearance of Graeco-Roman jewellery at Taxila. Alexander the Great had invaded and reached Punjab in 326 BC. Before his departure, he appointed a large garrison of Greek soldiers at Taxila, which was later withdrawn due to increased onslaughts by Chandragupta Maurya. After the fall of the Mauryan dynasty the Greeks of nearby Bactria re-annexed Taxila for another hundred years. This laid the foundation for the import of Greek art and culture in to the region. The Bactrian Greeks were succeeded by the Sakas and then the Parthians, who also remained partial to Greek art and revived many earlier Greek art traditions. In fact the Parthians, who supplanted the Sakas, were ardent Hellenists which largely accounts for the remarkable wealth of Greek and Indo-Greek jewellery made of gold and silver that made its appearance at Taxila in the first century AD.

Another major factor responsible for the appearance of a rich hoard of Greek jewellery in Sirkap was the opening of the trade routes through Parthia that connected India with the Mediterranean and facilitated their import.

A number of jewellery pieces found in Taxila bear a striking affinity with the contemporary art of Russia and furnish interesting evidence of commercial contacts between India and the Black Sea region—a curious off-shoot of the brisk Mediterranean trade. These Sarmatian ornaments probably found a ready market among the Saka-Parthian population of Taxila for their attractive design, colouring and purity of gold, as compared

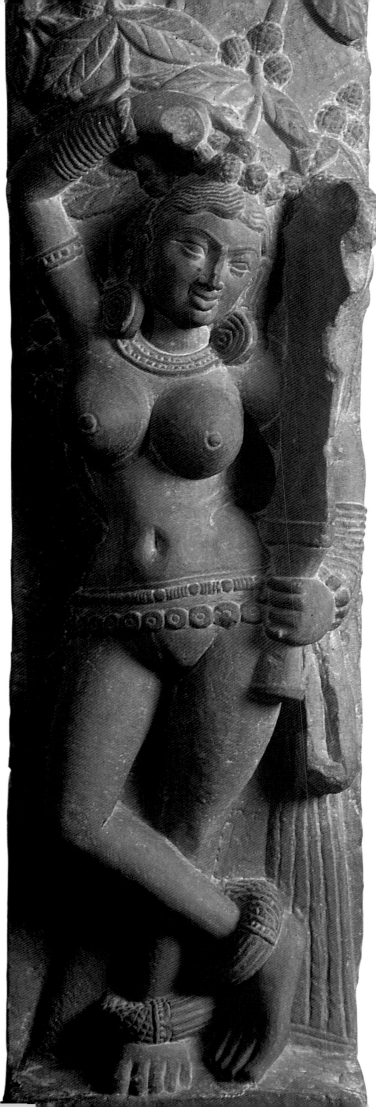

to the delicate Graeco-Roman jewellery in vogue at that time.

The actual specimens of jewellery found in Taxila and adjoining areas include ear-pendants, ear-rings, necklaces, girdles, breast chains, belts, amulets, pendants, brooches, and so on. Although a majority of them are Graeco-Roman, a few of the earlier pieces are of Mauryan, Scythic and Celtic origin. The decorative art-motifs, thus, occurring in Taxila jewellery are a mixed lot.

1. **The use of moulds :** Much of the jewellery from Taxila was made with the help of moulds and dies, like the stone moulds and the copper and bronze dies. The stone moulds were intended for the production of solid or hollow pieces of jewellery. The copper and bronze dies were meant for hammering out the heavier gold and silver sheeting. A large assortment of such dies, evidently cast in moulds, were found amidst a jeweller's stock-in-trade in the Saka-Parthian city of Sirkap.

2. **The technique of granulation :** This means the decoration of the gold surface with fine granules. This process was known in Greece and the Near East from very ancient times. It was also known to the jewellers of Egypt and was later practised in Greece, Italy and Asia Minor down to the Roman times. The granulation covering the whole surface, which is technically known as field grain work, can be seen as minute and fine as dust.

3. **Filigree :** Filigree was another technique employed in producing ornaments at Taxila. This was effected by soldering a fine wire to the surface of the metal; the wire being either plain, twisted, plaited into a chain or beaded.

4. **Incrustation :** The incrustation of gems is, no doubt, a very old Indian technique employed in the manufacture of ornaments. However, the Taxila jewellery exhibits a different technique called cloisonne.

The semi-precious stones used in jewellery at Taxila were carnelian, chalcedony, agate, onyx, garnet, jasper, lapis lazuli, turquoise and turquoise paste, black marble and others. The same semi-precious stones have also been used for incrustation by the Greek, Graeco-Roman and Graeco-Scythic jewellers.

Lady with sword standing under a tree. She is decked out with bangles, armlets, ear-rings, necklace and girdle. Stone. Kushana period, second century AD. Newal, U.P. National Museum, New Delhi, J. 275.

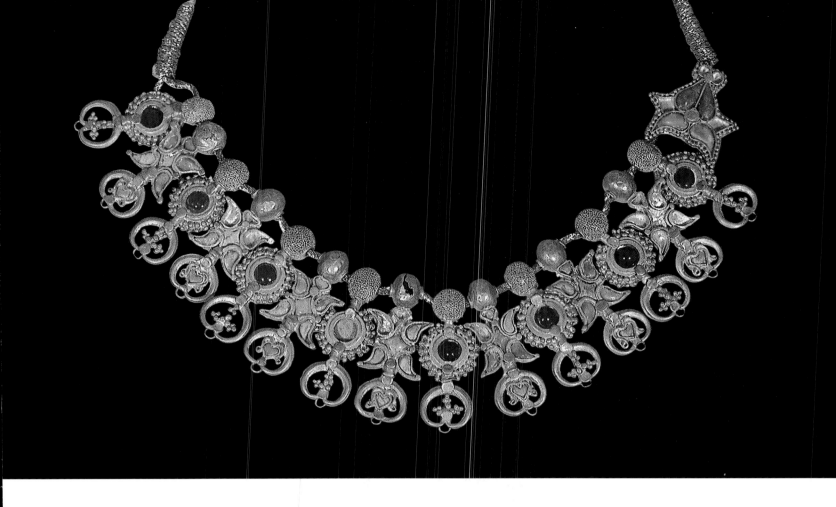

Necklace. *With gold terminals inlaid with rubies and turquoise.*
First century AD. Taxila.
National Museum, New Delhi, 49.262/6.

Ear Ornaments : The ear-pendants and ear-rings from Taxila and the adjoining sites present a considerable variety. They have been divided into six groups:
a) Amphora type are the earliest, belonging to the third or early second century BC.
b) Disk and pendant and bar and pendant types.
c) Leech and pendant type.
d) Flower and pendant type.
e) Ring type; which was a small ear-ring of solid gold with ends twisted back in a spiral round half or more of the ring.
f) Heart-shaped type.

Necklaces : The necklaces consist of gold and silver beads, pendants and the spacer beads. They are made of spherical beads with spacer circlets. Some of the silver necklaces are made of thirty-seven pendants with twenty spacer beads and two terminals.

Amulets and Pendants : The claw or tooth pendants, exhibiting numerous motifs like the swastika, the pipal leaf, the bell and the clubs were worn as amulets.

Brooches : Brooches were decorated with Greek mythological figures like the goddess Aphrodite, Psyche and Eros.

Hairpins : A large number of hairpins have been recovered from Taxila. An interesting example is of a gold pin decked with flat 'wheel' head.

Bangles and Bracelets : The gold and silver bangles, amulets and bracelets can be grouped into five types:
a) Solid heavy bangles with open knobbed ends.
b) Solid bangles with spirally twisted ends.
c) Hollow bangles of metal with expanded ends.
d) Solid or hollow bangles with ends shaped like a lion's head.
e) Open work bracelets with square 'gate' clasps adorned with jewels.

Torques : The torque (a necklace or collar, usually of twisted metal) is not a traditional Indian ornament; in fact, it is foreign to Greece and Italy as well. It is actually a characteristic Scythic and Celtic ornament. The specimens found at Taxila were no doubt worn by the Sakas or Parthians.

Anklets : Among the good specimens are four hollow silver double anklets of the Maurya-Sunga age.

Finger-rings : Although gold is the metal associated with Taxila, no gold ring has been found in Bhir Mound. The city of Sirkap has however yielded seventeen gold finger-rings, from the first century AD.

Some of the more elaborately made necklaces found in Taxila indicate the beginning of *kundan* (intricately carved delicate motifs) work which was later patronised by the Mughals.

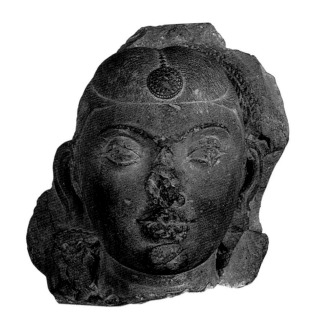

Female head with ornaments. The 'tika' is a head ornament worn at the parting of the hair and attached to gold strings. The ear-rings were called 'karnaphool'. Stone.
Kushana period, second century AD.
Mathura, U.P.
National Museum, New Delhi, 230.

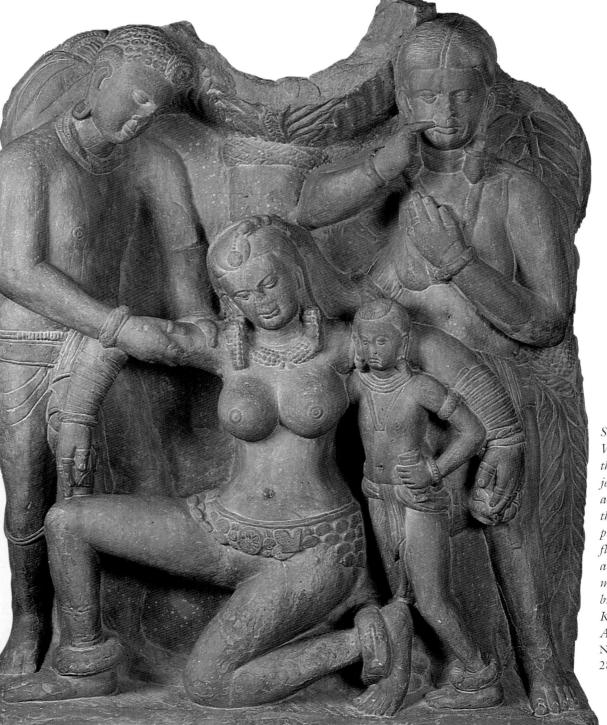

Scene of the famous courtesan, Vasantasena's house depicting the finest examples of Kushana jewellery. The head ornament is adorned with strings of pearls, the necklace is studded with precious stones, the girdle has a floral pendant and the bangles are probably made of ivory. The male figures exhibit ear-rings, bracelets and necklaces. Stone.
Kushana period, second century AD. Mathura, U.P.
National Museum, New Delhi, 2800.

Roman Jewellery of South India

South Indian jewellery has a long history—it is associated with the chalcolithic and neolithic sites of Karnataka and the early megalithic burials of Tamil Nadu. The remarkable finds at Adicchanallur near Tirunelveli, circa 800 BC, are probably the earliest examples occurring in Tamil Nadu. Another important hoard of south Indian jewellery recovered from a megalithic burial site at Suttukkeni, near Pondicherry (presently housed in Musee Guimmet, Paris) goes to suggests that the jeweller's art was in a high state of proficiency in south India long before the Christian era.

The brisk trade between south India and the Roman world at the beginning of the Christian era allowed a free and frequent flow of the Roman gold coins in the southern Indian peninsula. The beautiful Roman gold coins were often converted into necklaces and bracelets by Indian buyers. Several such jewels have been brought to light.

Although the Satavahana royalty and affluent members of society had developed a fancy for Roman gold jewellery yet, the Roman impact was peripheral and transitory. Thus the jewellery of the Satavahana and Ikshvaku periods, though exhibiting foreign traditions and techniques from the west, is basically Indian in design and character.

The jewellery of the Satavahana period which continued during the reign of Ikshvakus in the Deccan, particularly in the Andhra region, can be gleaned from the treatise *Gathasaptasati*, composed by one of the Satavahana rulers in the Prakrit language, which gives the names some of the jewels worn by the men and women of the Satavahana society. It is interesting to note that some of the north Indian ornaments of the Mauryan period were also commonly used in the Deccan during the Satavahana age. The sculptures from Amaravati also exhibit the use of jewel boxes (*samulgakas*) to carefully preserve costly jewels.

Head Ornaments : The men wore a turban (*ushnisha*) which was wrapped or coiled around the head. A large circular jewel was placed in the centre of the *ushnisha*. Another ornament, a *kirita* or crown was a cylindrical cap studded with gems.

The head ornaments for the women were the *chudamani* and the *makarika* (crocodile jewel), both being worn on the parting of the hair (*simanta*). The *makarika* or ornament with mythical fish-crocodile design remained very popular in south India.

Ear Ornaments : The most popular ear ornament was the *kundala*, as known from *Gathasaptasati*. The *kundalas* were of different types; the simplest being the crescent shaped ones often noticed at Amaravati. In one of the earlier sculptures of Amaravati, another variety of *kundala*—square

Royal couple in an amorous pose with attendant. The typical Satavahana jewellery consisted of bead necklaces, armlets, bracelets, girdle and ear-rings. The head ornaments were very pronounced. Stone.
Satavahana period, second century BC.
Pitalkhora, Maharashtra.
National Museum, New Delhi, 67.194.

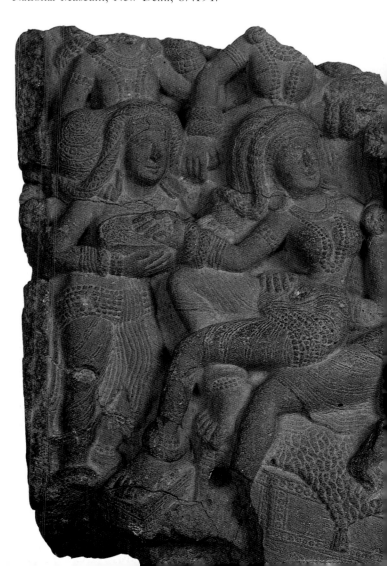

with a full-blown lotus flower, the stalk of which is curled on the earlobe—is noticed. The jewelled *kundalas*, as mentioned in the *Gathasaptasati*, were worn by men and women alike. The *patra-kundalas* or the golden ear-rings with the rolled palm leaf design were also popular.

Necklaces : The most popular necklace was the *phalakahara*, consisting of *phalakas* (gold slabs). Sometimes rectangular gems, instead of gold slabs, were strewn at regular intervals on the pearl necklace. The *kanthika* was set with precious stones, such as rubies and diamonds. The Jain *Kalpasutra* describes a necklace made of coins (*dinar*) called *urattha-dinara-malaya*. *Nishka*, a necklace still worn in south India, was strung with gold coins.

Bangles and Bracelets : The *Gathasaptasati* mentions a perforated bracelet, *jalavalaya*. Another kind of bracelet, known from the same source, was *kandora* or the golden string, which was twisted into an elegant rope design. Besides this, bangles were also made of other materials, such as ivory and rhinoceros horn. Similarly, armlets were worn both by men and women.

Girdles : The girdles were composed of a number of strings of gold, pearls and beads of precious stones. They were variously known as *rasana*, *mekhala*, *kanchi* and *saptaki*. The poem *Gathasaptasati* describes the *mekhala* as composed of dark beads. Another form of girdle, *rasana* was probably made of gold chains. The men wore a different kind of girdle, called *srinkhala*, a thick cord around the waist. Jewelled girdles were worn by the affluent members of society.

Anklets : Numerous varieties of anklets are known from ancient Pali and Sanskrit literature: *manjira*, *tulakoti*, *nupura*, *padangada*, *hamsaka* and *palipada*. The female figures at Amaravati are shown wearing *manjira* and *nupur* anklets, which had many coils. The *kinkinis* had small bells to produce a sweet jingling sound. The male figures of *yakshas* wore an *udarabandha* or a waist band.

Finger-rings : The finger-ring, *anguliyaka*, appears very late in Amaravati sculptures—around the third century AD.

The notable discovery of a goldsmith's entire stock-in-trade, which included moulds of various designs, crucible and so on, is positive evidence that the art of jewellery was booming in the Deccan in the Ikshvaku period. However the jewellery of south India and the Deccan overall remained somewhat plain and simple, as compared to that of Taxila.

The Roman influence on south Indian art and culture has received a lot of attention of late. It is amazing how traders from the Roman empire used to face a hazardous journey far across the seas on their simple sailboats to trade with India. They landed on the west coast from where they travelled through the jungles of the western ghats in Maharashtra, crossing the Palghat Pass (the Tamil Nadu-Kerala border) till they reached the south.

In India they bought ivory, spices, herbal products, pearls, diamonds, tortoise shell, silk, parrots, peacocks and so on. Pepper, called *yavana priya*, was most sought after by the Romans. What was coming to India were coins of gold and silver, among other things. The pure gold and silver coins flowed into the south Indian markets as bullion to meet the balance of trade payments. These were then pierced and used as ornaments and were much sought after for the value of the gold. In fact, the practice of wearing such necklaces seems to have continued in India well into the medieval period.

Most of the Roman jewellery in south India have come down to the present day as part of family heirlooms. The excellent collection of Roman jewellery presently housed in the Government Museum, Madras, was part of the treasure trove preserved for generations by the people of the Vellalore and Koneripatti villages in Tamil Nadu.

The jewellery recovered from Vellalore village in 1939 is of considerable significance, as it throws valuable light on the cultural and trade contacts between India and the Roman world during the first century BC and first century AD. A small village, Vellalore in Coimbatore district of Tamil Nadu, has yielded the Roman coins of emperor Tiberius, along with other Roman jewellery. The various articles recovered include

Facing page: **Gold jewellery**. *Adornment for the hands and neck include four rings with fish, dragon, lion and dancer motifs; an oval carnelian stone with a horse motif; a model of a bill-hook; a pair of floral beads and a gold pendant. First century BC to first century AD. Vellalore.* Government Museum, Madras.

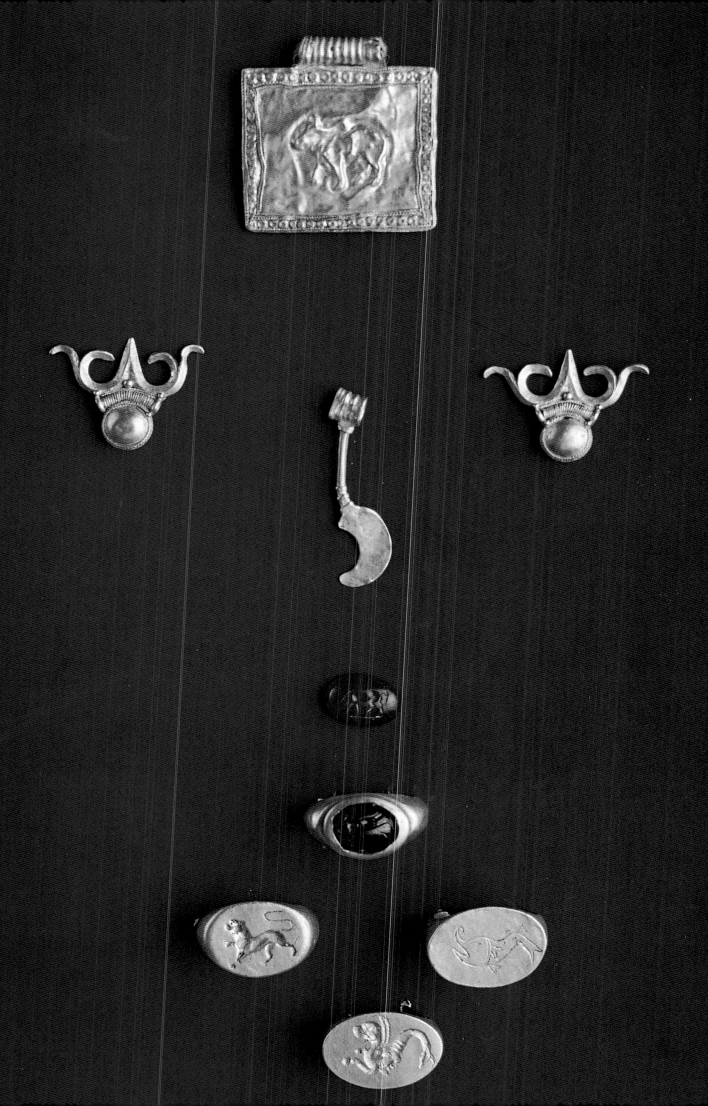

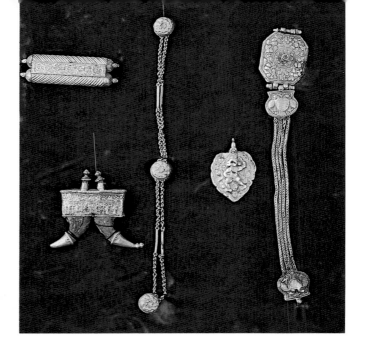

Pendant. *A tiger-claw pendant and a gold pendant with Hanuman. Three buttons with a connecting chain. A bracelet. Tenth to eleventh century AD. Deccan.*

ornaments for the fingers and the neck; four big rings with fish, dragon, lion and dancer motifs; a carnelian oval stone for a ring with a horse motif; a gold plate or pendant and so on.

The Gupta Period

With the establishment of the formidable Gupta empire, the political condition of the country stabilised. As a result trade flourished, science and technology made rapid strides and there was all round prosperity and development. It was a time of artistic effulgence and perfection and it is not surprising to learn that historians have dubbed it the golden era of ancient India.

The art of gems and jewellery reached its climax during the Gupta age. Many of the earlier ornaments were modified and fresh forms were introduced to suit the new tastes and social traditions.

The use of precious stones with splendid shades on the glittering surface of the gold became the characteristic feature of Gupta jewellery. It necessitated *Ratna-pariksha* or the examination of jewels; which is among the sixty-four subsidiary branches of knowledge in Vatsyayana's *Kamasutra*. Jewellery seems to have

A bejewelled Yaksha, guardian of the god of wealth. Stone. Satavahana period, second century BC. Pitalkhora, Maharashtra.
National Museum, New Delhi, 67.195.

An Ajanta painting from cave seventeen. A celestial nymph worshipping the Buddha, adorned with exquisite jewellery.

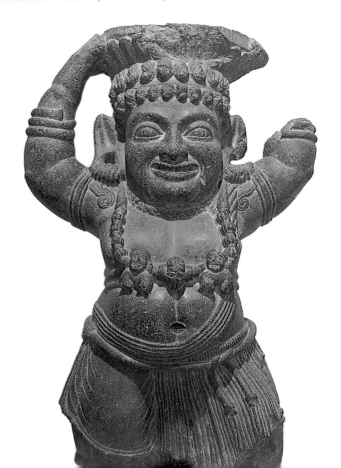

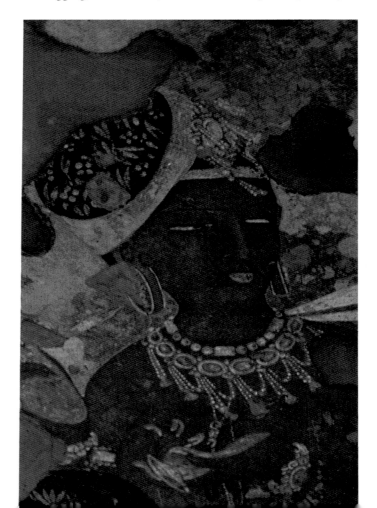

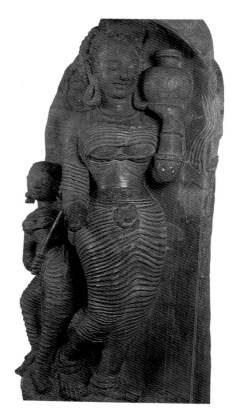

A life-size figure of Ganga standing on a crocodile. She is shown wearing head ornaments, a single-stringed necklace, bangles, bracelets, a girdle with a flower-shaped pendant and anklets with bells. Terracotta.
Gupta period, fifth century AD. Ahichchhatra, U.P.
National Museum, New Delhi, 1.2.

This magnificent sculpture represents a female huntress carrying an arrow in her right hand and possibly a bow in her left. She wears head ornaments, ear ornaments, necklaces, bangles, armbands, an intricately carved girdle with silver bands and a pronounced central floral motif and beaded anklets. Stone.
Hoysala period, twelfth century AD. Mysore, Karnataka.
National Museum, New Delhi, 599.204/2.

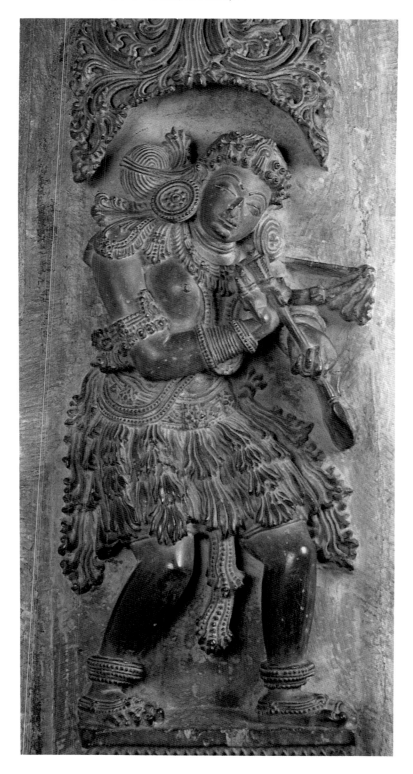

been a social must during the Gupta period and ornaments were worn all over the body.

Head Ornaments : During the Gupta age, the *kiritika* was a must for the kings. The gems, *chudamani* and *makarika* (crocodile shaped jewel) were commonly worn by the ladies on the parting of the hair; the former at the back and the latter on top of the head. The ornament, *chudamani* was shaped like a full-blown lotus with petals composed of pearls and precious stones. The great poet Kalidas mentions ornaments like the *ratnajala* (jewelled festoons) and *muktajala* (pearl festoons) which were worked into the hair of the ladies.

Ear Ornaments : The ear-rings or *kundalas* were of many shapes. The *makara kundala*, showing fantastic animals with curled snout and the *manikundalas* or ear-rings fitted with jewels were very popular. The trend of decorating the hair with a pearl string was started in the Gupta

age. Ear-rings shaped like leaves (*patra-kundalas* and *pati-kundalas*) seem to have been in fashion.

Necklaces: The most common necklace of the Gupta period, as seen in the sculptures, was the *ekavali* which consisted of a single string of pearls, with a large sapphire in the centre. Kalidas on the beauty of this ornament says, '...remarkable is the beauty of the pearl itself, to say nothing of its impact when combined with the radiant sapphire'. Another scholar of that era, Varahamihira mentions a large variety in necklaces, named after the number of strings. For instance, the *induchhanda* (one thousand and eight), *vijayachhanda* (five hundred and one), *devachhanda* (eighty-one), *rasmikalapa* (fifty-four), *guchha* (thirty-two) and so on. *Nakshtramala* was a necklace which had twenty-seven pearls in one string.

Girdles : The girdle was called *hema*, which also suggests its material, gold. *Hemasutra* was probably a chain of gold with precious stones in the centre. Girdles of the design and metal popular in earlier ages, continued to be so. In fact, the *rasana* with a melodious sound of chains and the *kinkina* which had lots of small bells attained greater popularity in the Gupta period.

Bangles and Bracelets : Various names such as *valaya*, *angada* and *keyura* were used for the bracelets and armlets during the Gupta age. They were made of gold and encrusted with precious stones. The *keyura* were shaped like an animal's head. A *keyura* without tassels was known as an *angada*.

Anklets : The terms *nupura* and *maninupura* are found mentioned in the literature of the Gupta period. The *maninupura* was studded with gems. Another ornament mentioned in treatises of that time is the *tulakoti* which meant anklets with two ends, each bearing a slight cubical enlargement like those at the ends of a balance beam.

Finger-rings : The finger-ring or *anguliyaka* seems to have become popular during the Gupta age. Kalidas in his celebrated play *Abhigyana Shakuntalam* mentions *manibandhanas:* finger-rings with jewel tops.

The Pallava and Chola Periods

Both the men and women in the Pallava and Chola periods were fond of ornaments. The carved male figures in the temples belonging to that era show figurines wearing ear-rings of different types, armlets, waistbands and leg ornaments. The ear-rings of the Chola sculptures belonging to the ninth and tenth

Shiva as the divine dancer. He wears a high crown, an ear-ring on the left ear and a profusion of other jewellery. Bronze.
Chola period, tenth century AD. Thiruvarangulam, Tamil Nadu.
National Museum, New Delhi, 55.40.

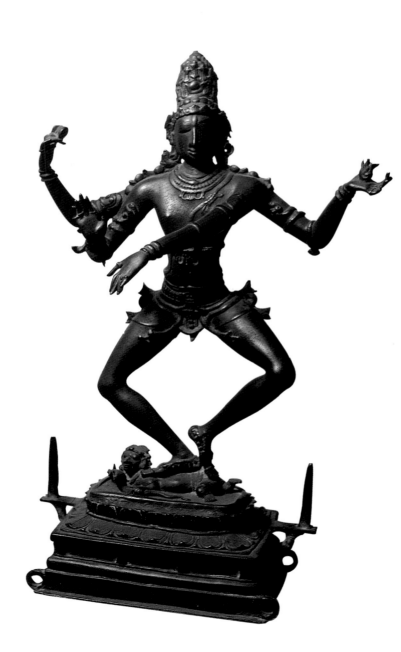

centuries were round, circular discs studded with stones.

Jewellery worn by men consisted of *keyuras* and *valayas* for the upper arms, bangles known as *khadi* and *gajulu*, bracelets *svechitika* or *barjura*, wristlets *ruchika* and *chitika* for the lower arms and elaborate girdles with tassels, *srinkhalas*.

The women wore *agrapatta* or *cheruchukka* which consisted of two pearl strings with a circular floral ornament on the forehead called *simanta*. Another jewel for the head was a gem-studded band with bejewelled flowers dropping on to the forehead, appended to a set of three concentric bejewelled rings worn high up on the head. A similar ornament for the hair bun or knot further decorated the head.

There were two types of ear ornaments for women which were peculiar to this period: one resembled a bunch of grapes and another was a geometrical cluster of gems.

Although actual specimens of the gems and jewellery of south India have not survived to this date, it is not difficult to understand their nature and form; the sculptures found in various temples and other excavated sites provide ample evidence of this.

Even a casual glance at the sculptures of the early Chalukya era would show that gold and pearls were in great demand and that these jewels were heavy and not delicately fashioned. The floral motifs and designs of the jewellery worn by the male and female sculptures of the Kalyana Chalukya period are decidedly more delicate and attractive.

The Hoysala period of south Indian history exhibits a peak in the art of jewel making. The most intricate designs, delicate workmanship and refined treatment were used to make various ornaments worn by both, men and women. The ornaments as depicted in Hoysala sculptures seem to suggest a real love for ornaments as the figures are often overladen with jewellery. The elegant forms and the rich variety of pearl garlands, necklaces, ear-rings, bangles, armlets, anklets and girdles are simply superb and enormous in number. One can only wonder at the ability of the goldsmiths who created these thousands of patterns and designs.

The Chandella Period

The sculptures of Khajuraho in central India bear testimony to the fact that the men and women during the Chandella period wore a whole variety of ornaments.

Head Ornaments : Women wore a stud of gold or silver on the parting of the hair, attached with a chain. The ornament, which is still used in central India, is known as *bor borla*. Another ornament used on the forehead was shaped like a lotus flower and called *sisaphula* or *rakhdi*.

The ladies of the royal household wore a crown which was conical in shape and had a chain made of pearls (*muktajala*) which attached it to the hair. On the top of that a tiara of intricate design was worn by the ladies of privileged birth.

Ear Ornaments : Both men and women were fond of ear ornaments. A rich variety of such ornaments (*kundalas, balas, phula jhumaka* and *karnaphula*) were common. The *bala* or gold ring was inserted into the ear-lobes, and was studded with pearls and precious stones. The *karnaphula* was a star shaped or flower shaped ear-ring which

Ganga, the goddess of the river Ganga or Ganges, adorned with jewellery. Stone.
Khajuraho Museum, M.P.

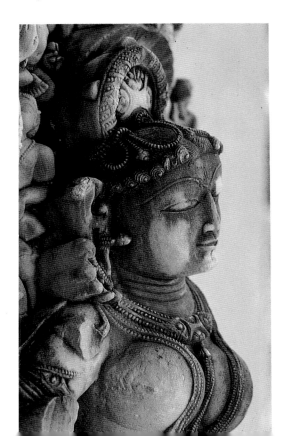

was sometimes appended with a round bud shaped drop. Some of the ear-rings were made of several concentric rings with pearls on the outside. The *phul jhumka* was another ornament shaped like a flower; it was heavier than *karnaphula* and was fastened to the ears with a beaded string.

Necklaces : Both men and women wore necklaces with leaf shaped or square pendants held together by a twisted cord or beaded string. In the case of women, a necklace was a longer bead string and hung low. Sometimes, the string consisted of two or three rows of beads or pearls. The necklaces for men were devoid of such add-ons. Besides, other neck ornaments such as *kantha* (torque) and *hansuli* (a kind of necklace) were equally popular.

Bangles and Bracelets : The armlets noticed in the sculptures of that era consist of a single row of beads or pearls. Heavy cylindrical armlets, decorated with beaded borders, often with outer rims raised, are also seen on the figurines at Khajuraho. Plain metal armlets, probably of gold, were also worn.

Among the bracelets (*valaya* or *kangana*) beaded *kanganas* were most popular. The beads being round, cylindrical and large. The double bracelets with a central clasp and very broad metal bracelets, covering half of the arm were also in vogue.

Finger-rings : The finger-rings, both simple and bejewelled, were quite popular in the Chandella period. The interesting part is that the rings were worn on the thumb, like the archer's rings of the Mughal era. The finger-rings were also worn on the index finger; they were either simple or studded with plain beads.

Girdles : The girdles (*mekhala*) used during the Chandella period were of different varieties: from a simple girdle with only a single string of beads, to elaborate girdles consisting of an ornate belt with a central clasp worn on the waist. A more interesting feature in some of the girdles are the small bells suspended with chains and hanging down to the thighs in order to produce a rhythmic tinkle when the wearer moved.

Anklets and Toe-rings : There were a variety of ornaments for ankles and toes, ranging from plain to highly ornate ones as seen in the carved figures at Khajuraho. The anklets consisted mostly of

beaded strings and a series of square pendants. Often they are made of two or three rows of beaded strings and some of them are made of twisted cord design. However, the courtesans used different types of anklets made of small metal shells (*kinkinis*) strung on a cord. The toe rings, used by males and females alike, were either plain or beaded.

The onslaughts of Islam caused great political turmoil and social disorder in the country. Initially, Indian arts and crafts suffered a great setback. With the lapse of time, however, Muslims settled and mingled with the main cultural stream of the country.

A splendid Khajuraho figure elaborately adorned with jewellery. Stone.

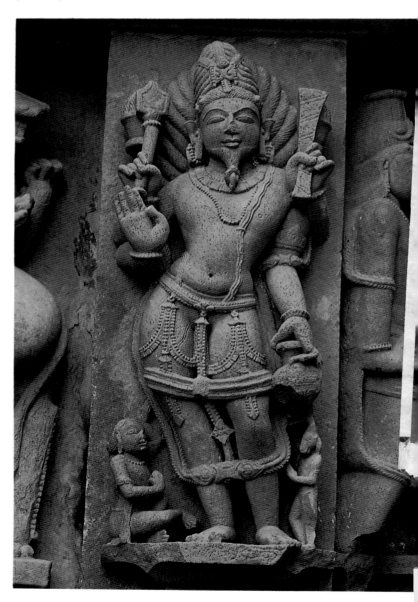

The Kakatiya Period

A large variety of ornaments covering entire bodies of the male and female figures of the Kakatiya sculptures, provide positive evidence that their goldsmiths were not far behind in skill.

Head Ornaments: There were large number of head ornaments such as the *cherubottu, jalli* and *bottubilla*. The *cherubottu* was a strap like ornament studded with precious stones, which was worn at the beginning of the parting of the hair, *jalli* was made of pearls and the *bottubilla* was worn at the back of the head.

Ear Ornaments: Among the ear ornaments the heavy *kundalas*, very big in size almost covering half the face and hollow inside, were greatly in vogue.

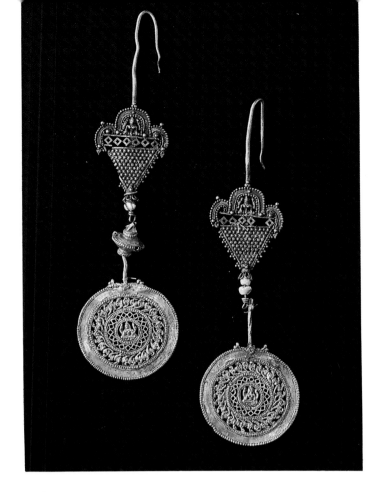

Gold ear-pendants. *The upper portion consists of a loop and a triangular piece with a trefoil arch at the top with the image of Lakshmi seated in the middle arch of the trefoil. The lower portion is shaped like a medallion with images of Lakshmi on both sides.*
Eleventh century AD. Narasapur, Warangal Distt., A.P.
State Museum, Hyderabad, 6/1357/F.

Moulds. *Five pieces of moulds for the making of jewellery in different shapes.*
Seventeenth century AD. Bhukkarayasamudram village, Anantapur District, A.P.
State Museum, Hyderabad, L (25) 1983.

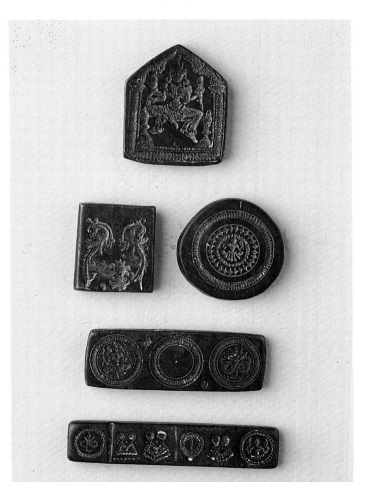

Necklaces: A large variety of neck ornaments had come into vogue by this period. An *ekavali* was formed of pearl-strings, and an *ekavali* with a big pearl in the middle was called *sirsaka*. It was suspended from the neck, forming a loop below the breasts. A necklace with five pendants or five gold straps, each studded with gems, was known as *panchaphalaka*.

Armlets: Armlets were used by both men and women. The sculptured male figures of the Kakatiya period are adorned with armlets called *venki*. There were also spiral armlets known as *keyuras* or the *danda kadiyas*.

Bracelets: Five different varieties of bracelets are found depicted in the Kakatiya sculptures. There are the spiral or ring type, thick bracelets decked with jewels, beaded type, cylindrical and chain type.

Girdles: The sculptures from the temples of Telengana in south India which are also of this

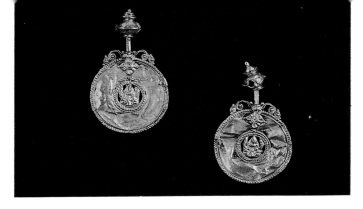

Gold ear-rings. *Depicting the goddess Lakshmi.*
Eleventh century AD. Provenance unknown.

period, exhibit an unique ornament for the
shoulders called *skandhamala*.

Foot Ornaments: Various types of ornaments to
adorn the foot had come into vogue during the
Kakatiya period in the Andhra region. The male
dancers carved at the Palampet temple in Warangal
district of Andhra Pradesh wear heavy anklets made
of beads. Many sculptures of the women of this era
are shown wearing toe rings called *mattiyalu*.

*Mahishasuramardhini, the goddess fighting the demon and
his retinue with majestic poise, wears rounded ear-rings,
necklaces, armlets, a girdle with pearly festoons and heavy
anklets. Stone.*
Kakatiya period, thirteenth century AD.
Provenance unknown.
National Museum, New Delhi, 59.153/171.

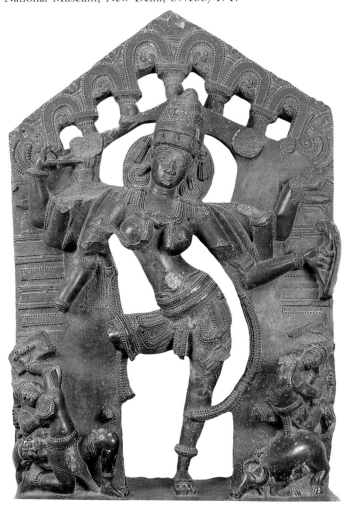

The Vijayanagar Period

The taste for extravagant and lavish ornaments
underwent a change during the Vijayanagar
period. There is a marked slant towards simplicity
and elegance.

There is an interesting account by Bahubali, a
poet of this period, in which he describes the
jewels worn by a courtesan in his famous work
Nagakumara Charita: '...she adorned her person
with valuable ornaments, such as the golden bells
strung into a yellow silk anklet, brassieres of a
network of pearls, with an attached garland of
three strings of pearls, necklaces studded with all
the nine varieties of gems, a sun shaped ear
ornament, wristlets and bangles made of diamond
dust.'

Abdur Razak has remarked that the court
dancers were wealthy, for each of them was
bedecked with pearls and gems of great value and
were dressed in costly ornaments. Domingo Paes
notes that 'no one can fitly describe to you the
great riches these women carry on their persons.
Collars of gold, fitted with diamonds, rubies,
pearls; bracelets on their arms and upper arms,
girdles below and anklets on the feet.'

Ear Ornaments: A variety of ear-rings are found
adorning the male and female sculptures of the
Karnataka region of south India. The type of ear-
rings commonly noticed in the sculptures of the
early Chalukya period are the large circular
kundalas. During Vijayanagar times the *muktodaka*
ear-rings, which were made of pearls, were very
popular. Besides, the ladies of the royal household
used to wear *vajragarbha*, ear-rings studded with
diamonds in the centre. Men wore sun shaped ear
ornaments of different sizes. The *sopan krama
vinyasta kundala*, which had the precious stones
set along with a large ring to cover the entire ear,
seems to have come into vogue during the later
Chalukya period.

Head Ornaments: The ornaments used for the
head and hair were of great variety. For example,
baitale bottu was a pendant used on the forehead.
Another jewel was called *ragate*, a circular jewel to
be used on the back of the head, was studded
with precious stones. The *jadde hoovu* (floral jewel

on the plait), *jadde bangara* (whole plait covered by an elaborate gold disc), *nagara* (a gold ornament decorated with tiny gold beads) and *kuchchu* (a beautiful tassel decorating the end of long hair) are some ornaments for the head which are used even today in Karnataka.

Arm Ornaments : The ornaments covering the shoulders and upper arms, *keyura* and *bhujabhusana*, were strings of pearls or pendants of pearls and gold beads joined together to cover the shoulders. The Hoysalas added the tassel and cluster of pearls to the simple *keyura* of earlier times. The *keyura* of the Vijaynagar period, however, seem to have been made of metal sheet.

Necklaces : The *kantha* or *hara* was worn on the neck and marked the status of a person. Necklaces were made of gold or pearls, both for men and women. Necklaces were given various names, like *ekavali* (one string), *trivali* (three string), *panchavali* (five strings) and *saptavali* (seven

An intricately carved masterpiece of Mohini. Stone. Western Chalukya period, twelfth century AD. Karnataka. National Museum, New Delhi, 50.190.

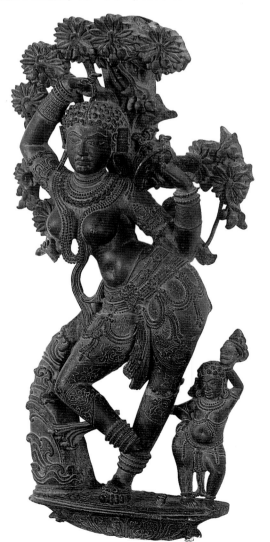

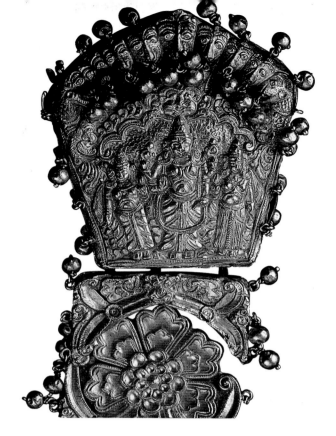

Gold braid. *The plait ornament is made of twenty-one separate pieces. The top pendant shows Vishnu flanked by Sridevi and Bhudevi. The last pendant is in the form of a fish indicating the first incarnation of Vishnu. Sixteenth century AD. Ghatt village, Gadwal taluk, A.P. State Museum, Hyderabad, T.T. No. 17/1980.*

strings), depending on the number of strings in the necklace. The *thanaharas*, which covered the entire chest were commonly used.

Wrist Ornaments : Wrist ornaments called *prakoshtha valaya* were worn enthusiastically by both men and women. The thick wristlets were known as *kadaga* or *kankana*. The somewhat simple *kadagas* were used during early Chalukya times, however with time they became quite elaborate. The difference between the *kadaga* and *kankana* was that the former did not make sound, whereas the latter produced a jingling sound when the hands were moved. During the Hoysala period, the *kadagas* were embedded with rows of tiny pearls and golden beads. The Vijayanagar period nobles wore elaborately patterned wristlets. People used finger-rings studded with pearls and gems called *navaratan* (nine gems).

Ornaments for the Waist and Lower Limbs : Among the waist ornaments, girdles popularly called *katisutras*, *kanehidhama* and *vodyana* were

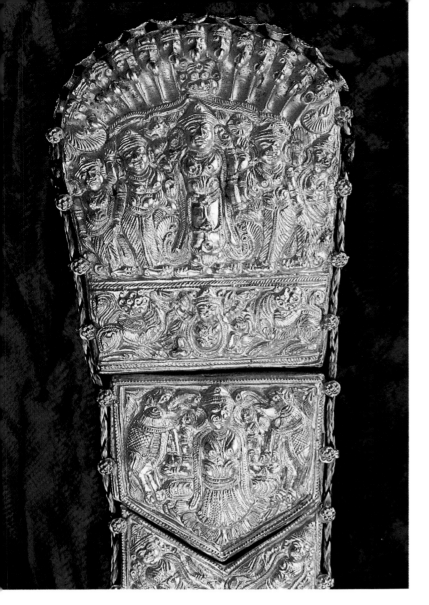

Gold braid. *Made up of several pendants in the form of plaits. The top rectangular pendant shows Rama's coronation. Rama is flanked by Sita and Bharata on one side and Lakshmana and Shatrughna on the other. They are represented under the canopy of the serpent Adisesha, suggestive of supreme royalty.*
Sixteenth century AD. Ghatt village, Gadwal taluk, A.P.
State Museum, Hyderabad, T.T. No. 17/1980.

The emergence of Islamic power in the Deccan and south India changed the character and form of jewellery of the Deccan in particular. The Sultans of Bijapur and Golkonda held Persian culture in great esteem and hence, the earlier costumes and jewellery of the period were largely influenced by the court traditions of Persia. The artisans and craftsmen of the Vijayanagar empire were rehabilitated by them and commissioned to work for the Islamic courts. This is why the jewellery of the medieval Deccan exhibits a subtle blending of the traits and traditions of the courts of Vijayanagar and Persia.

After the conquest of south India by the Mughals, the influence of north Indian court traditions appear to have affected the quality and character of south Indian jewellery. Thus, the jewellery of the medieval Deccan presents a colourful synthesis of the Vijayanagar, Persian and Mughal art traditions.

Jewellery was a rage, cutting across all sections of society, both in the Qutb Shahi and Asaf Jahi periods. Thevenot, the French traveller, writing about the city of Golkonda remarks, '...a large number of good jewellers lodge in a Palace at Golkonda. The workmen of the castle are taken up above the king's common stores, of which he has so many that these men can handle work for anybody else.'

The precious diamonds from the Golkonda mines, lustrous Arabian pearls, particularly from Basara, pigeon-blood ruby from Burma, dark blue sapphire from Kashmir, emeralds from the Udaipur mines and other precious and semi-precious stones like coral, agate, topaz, amethyst and so on were greatly sought after to make costly jewellery for the nobility. Even the poor people wore ornaments which were made of beads of semi-precious stones, base metals and *bidri* (metal inlaid with silver). Flowers were also used by the ladies to adorn themselves. Thus, the extensive use of jewellery was popular in the state of Hyderabad right from its inception.

In fact, gems and jewellery gained so much importance in Golkonda and Hyderabad that they found mention in various contemporary literary

used. They were attached with gold strings, pearl strings, gem pendants and even bells which tinkled. During the Hoysala period, beautifully carved *anduges* or foot ornaments were introduced. *Anduges* were quite heavy and were fixed by a screw and lock device. The toe rings were held by delicate chains which enhanced the beauty of the feet. The toes of the feet had different rings with special names.

Gold signet ring. *Studded with 'navaratan' or nine stones in the form of a full lotus with stylised petals. Seventeenth century AD. Golkonda, A.P.* State Museum, Hyderabad, 2/1970-71.

works. For instance Mohammad Quli Qutb Shah in his famous *Diwan*, popularly known as *Kulliyat*, gives a graphic description of the jewellery of the ladies of his harem. A number of ballads composed during the Qutb Shahi and Asaf Jahi periods, such as *Qutb Mushtari* by the famous court-poet, Wajhi, *Maha Paikar* by Ahmad Junedi, during the reign of Abdullah Qutb Shah and *Chahar Darvish* by Mohammad Ali Khan 'Shouq', who lived during the reign of Asaf Jah II, make specific mention of ornaments. Even the popular work, *Chakki Nama*, comprising folk songs of the Qutb Shahi era, refers to the names of various contemporary ornaments.

Qutb Shahi dynasty

As stated earlier, there are a number of ballads of the Qutb Shahi era which refer to the various ornaments used by the male and female members of society. Some of the ornaments of the Vijayanagar times continued, whereas the other new ornaments could have been introduced after the advent of the Muslims in the Deccan.

Head ornaments : Various ornaments were worn on the head during the Qutb Shahi era. Principal among them were *taj* (crown) with *turra* and

jegha, *shees phul*, *jhumar*, *tika*, *jhala* and *gulsari*. A *jhabi* was worn on the braid. *Jhala* was worn on the forehead with the help of a pearl string.

Nose and Ear Ornaments : *Phulri*, *makra* and nose pearl were worn in the nose which was pierced, whereas *karanphul*, *bali*, *goshpara* and *janjhar* were meant for the ears.

Necklaces : The *galsari*, *hansuli*, *haikal*, *har*, *kantha*, *moti-ki-ladi*, *hamall*, *gundhi*, *halaq* and *samar* were worn around the neck.

Bangles, Bracelets and Finger-rings : The armlets were known as *bazuband* or *dastband*. The *kanganas* to be worn by women were bracelets studded with costly gems. *Kada*, *joda* (bangles), *chhalla* and *angustri* (ring) were worn on the hands.

Foot Ornaments : *Ghunghroo*, *paichan*, *payal*, *khal-khal*, *zanjeer*, *lulu* and *bichhawa* with the golden strings added to the delicate beauty of the feet.

Asaf Jahi dynasty

After the conquest of the Deccan by Aurangzeb in 1687 AD, the influence of Mughal culture became more predominant in Hyderabad. The style and fashion of dress and jewellery of the Mughal court were enthusiastically introduced and adopted by the Hyderabad court.

Head Ornaments : Lakshmi Narayan Safiq in his *Tasveer-e-Janam* mentioned a few other names of ornaments which were worn on the head. He talks about a head ornament which was known as *mirza-be-parwah*, *jabhi*, a gold disc worn on the braid of women and *moti-ki-ladi* which was worn on the parting of the hair (*mang*).

During the Asaf Jahi period *tika* was worn on the forehead, similarly the *moti-ki-ladi*, with three strings of pearls, was used at the parting of the hair. *Shees Phul*, *mirza-be-parwah*, *chand* and *jabhi talai* were the head ornaments. *Choti-ka-tabiz* was put on the braid.

Necklaces : The *champakali* (made of emerald), *thussi*, *kanthi* and *chintak* were worn on the neck. The pearl necklaces such as *chavlada*, *panchlada*, *satlada* and others depending on the number of strings or *lada* (*char*, *panch* and *sat* mean four, five and seven respectively) were named based on the number of strings in the necklace.

A pearl necklace with emerald or ruby studded pendants was called *dhukdhuki*, *haikal*, *hansuli* and *har;* these were worn by young children. *Haikal*, *zanjeer*, *urbasi* and *chandrahar* were different types of necklaces used by ladies.

Ear and Nose Ornaments : Karanphul, *bali*, *bala*, *dur bali* and *chand bali*, *jhala*, *jhumaka*, *bejan* and *sailah* were ear ornaments. *Ladli* was a gold chain attached with the *chand bali* to fix in the ears. *Goshwara* was also an ear ornament which continued down from the Qutb Shahi era. It was fashionable for the ladies of the early Asaf Jahi period to pierce their ears in five places—each for different ornaments. *Nath*, *bulaq*, *mogra* and *nak-ka-moti* were the nose ornaments.

Hand Ornaments : Dand-ke-kade, *kangan*, *panhuchi* and *chudi* were worn on the wrists by the ladies of this period. *Arasi*, a very popular thumb ornament, was fitted with a small mirror. Besides, *anguthi*, *chhalle*, *moti choor-ke-chhalle* made of gold and silver (also known as *ganga-jamuni*) were worn on the fingers.

Foot Ornaments : Zanjeer, *pajeb*, *payal*, *khal-kal*, *ghungroo*, *pejan* and *kada* were meant for the ankles and produced a tinkling sound when the wearer walked. Similarly, *gokhuru*, *ghol* and *chhalle* were worn by the ladies on the toes of both feet.

Apart from being used for personal adornment, ornaments also formed an integral part of the royal gifts given to nobles for good and faithful service to the king. Such royal gifts were known as *Sarapa*, which included a *sarpech*, *sarpatti*, *jegha*, *turra*, *kanthi*, *har*, *bazuband*, *dastband* and *samaran*.

Symbolic Jewellery of South India

In south India, jewellery was designed to fulfil various ritualistic requirements of different communities. The size and shape of an ornament sometimes denoted the caste or creed of its owner. Some ornaments were meant to exhibit the marital status of women.

Pendant. *A Lakshmi 'tali' (marriage-necklace) in gold with a temple dome above and a bell at the base. Goddess Lakshmi is shown in the centre.*
National Museum, New Delhi.

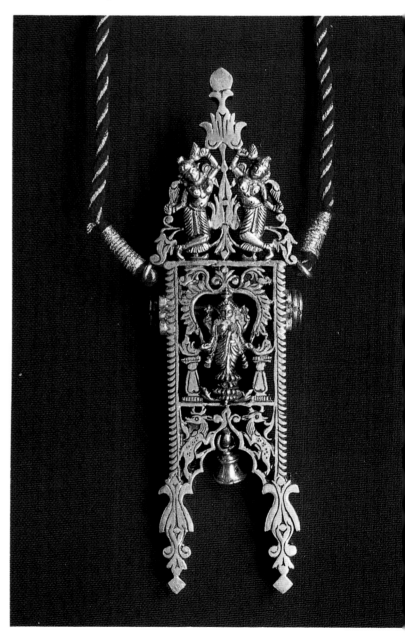

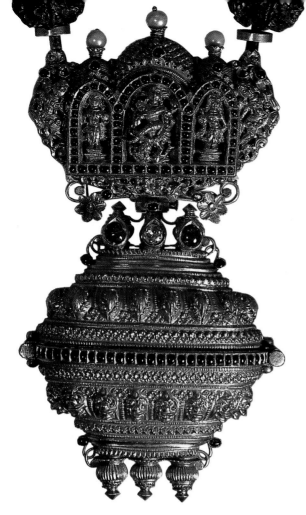

Pendant. *A gold pendant showing Lord Nataraj with attendants.*
Nineteenth century AD. South India.
National Museum, New Delhi, 89.1009.

Necklaces : In south India, women wear a particular ornament called *tali* or *mangalyam*, which is roughly equivalent to the western wedding band and marks the wearer's married status. This ornament is never removed from the neck of a married lady till her husband is dead. The *tali* appears to be amongst the oldest ornaments in south India as references to it have been found in the earliest Tamil literature. Initially its shape was like the teeth and claws of various animals, and was worn as a protective amulet.

Subsequently, it came to be associated with the wedding ritual. One of the earliest mentions of tying the *tali* occurs in the description of the marriage of Devasena with the warrior-god Skanda, in a passage of *Skanda puranam* (twelfth century AD) when the bridegroom ties a thread around the bride's neck. By tying a *tali* around the bride's neck the bridegroom confers on her the status of *sumangali*, the auspicious married woman.

The shape, design and size of a *tali* varies according to the sectarian affiliations of its wearer.

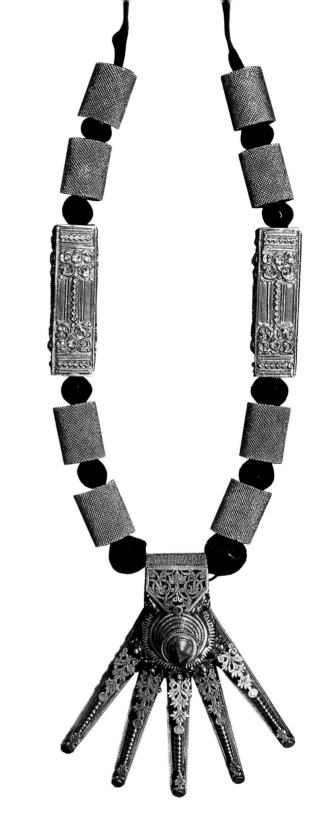

Gold necklace. *A 'tali', (marriage-necklace) is a part of the ceremonial jewellery of the Chettiars, a merchant caste. Nineteenth century AD. South India.*
National Museum, New Delhi, 89.1037.

31

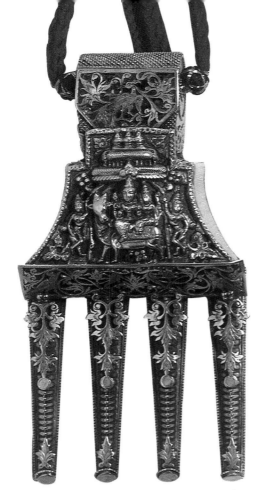

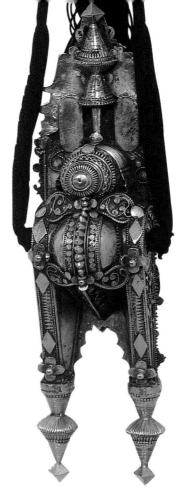

Pendant. *A marriage-necklace depicting Shiva and Parvati on the Nandi bull.*
Late nineteenth century AD. South India.
National Museum, New Delhi, 88.620.

Pendant. *A gold marriage necklace showing the dome-like 'gopuram' with a celestial floral motif.*
Mid-nineteenth century AD. South India.
National Museum, New Delhi, 89.1013.

For example, Nattukotai Chettiar (merchant caste) ladies, belonging to the wealthy business community, wear *talis* which could be twelve to fifteen centimetres long. The forked *tali* worn by Tamil women is shaped like *Nandi pada* (Nandi's feet), as they are the worshippers of Siva and Nandi is his carrier bull. The *tali* worn by the ladies of the Iyer community would depict a Siva-linga (phallic deity). Similarly, ladies belonging to the Iyengar Brahmin family, who are the worshippers of Vishnu, wear a *tali* which usually bears the Vaishnavite symbols, the *chakra* (circle) and *sankh* (conch).

Likewise, the wedding necklaces of south Indian women also indicate caste and community. The Chettiar marriage necklace, known as *kalata uru*, consists of four distinctive pendants shaped like a hand called *athanams*. In Tamil, *kala* means neck and *uru* means bead. The hand shaped pendants possibly represent the tiger's paw as a mark of protection to its wearer. The central pendant usually bears the figure of the goddess of wealth, Lakshmi and is called the *Lakshmi athanam*. Such a necklace generally comprises thirty-four gold beads and different types of

pendants strung together on twenty-one strands of turmeric-dyed thread twisted together. The necklace, *kalata uru*, is usually worn at the time of the wedding and then put aside as its weight makes it impossible for anyone to wear it daily. A woman may wear it again at her son's wedding or to celebrate the sixtieth birthday of her husband.

Another type of necklace, the *kasumala* is composed of gold coins; it can be as much as a metre long and often has more than one hundred coins. The figures of gods and goddesses are also found depicted here. Yet another type of necklace, a popular wedding gift to a lady by her close relatives, is the jasmine-bud necklace. About a metre long, it consists of one hundred gold flower buds.

In south India, the indigenous tradition of depicting the figures of gods and goddesses on jewellery continues till today, though the shape and size of ornaments have considerably changed.

Head Ornaments : The typical south Indian braid ornaments (*choti*), popularly known as *jadanagas* or hair serpents, are associated with snake iconography. *Jada* means 'hair', and long black

hair falling down to the knees are supposed to resemble the black cobra. Since the body of the cobra has a long spine with small segments joined together, the *choti* also consists of a numbers of small sections with the top shaped like a hooded cobra, whereas the rest represent the coils of the snake. South Indian women are traditionally very fond of wearing flowers in their hair and hence, the segments of the braid ornament are sometimes designed as flowers. The row of flowers, gradually diminishing in size, form a beautiful 'spine' for this long, elegantly tapered piece of jewellery.

Ear Ornaments : Besides this, south Indian ladies wear a variety of ear-rings which again have a very complex composition. Here, again the snake symbolism occurs in various sophisticated forms. The *pambadam* ear-rings (*pamba* means snake) exhibit various geometric elements, including sphere, circles, cones, arches and trefoils. The shapes are made of sheet metal and have flat polished surfaces. *Pambadam* ear-rings are still worn in south India and are crafted by village goldsmiths using the traditional moulds and techniques, handed down over the centuries. The various parts of the ear-rings are made by hammering gold sheets into dies, and the parts are eventually assembled and soldered together.

Yet another type of ear-rings, *mudichu* (twisted snakes) are equally popular, which are rings made of woven gold wires. Several *mudichu* can be worn in each ear or with *pambadam* and other ear-rings. The *mudichu*, though made of gold, are worn mostly by the women of the poorer sections of society.

In the extreme southern parts of India, women wear multiple ear-rings; suspended mainly from enormously dilated ear-lobes. A peculiar custom among the Kuratti women was to pierce the ears of young girls and provide them with heavy lead ear-rings, called *kunakku*, to lengthen their ear-lobes. *Tandatti*, another massive ear-ring made of gold leaf filled with wax was given to

Left: **Head ornament.** *A braid set with diamonds and rubies, enamelled in red floral design with the the reverse enamelled in white.*
Early nineteenth century AD. Rajasthan.
National Museum, New Delhi, 57.105/1.

Right: **Head ornament.** *This head ornament is filled with lac on top. Pendants show the twelve 'jyotirlinga' or deities.*
Nineteenth century AD. South India.
National Museum, New Delhi, 94.85.

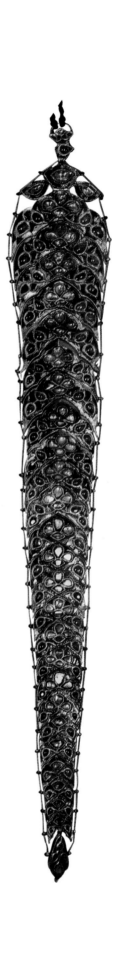

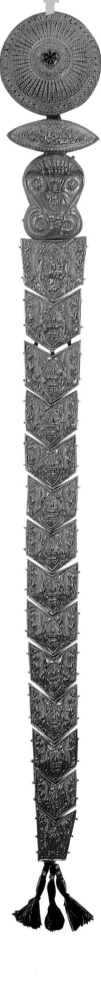

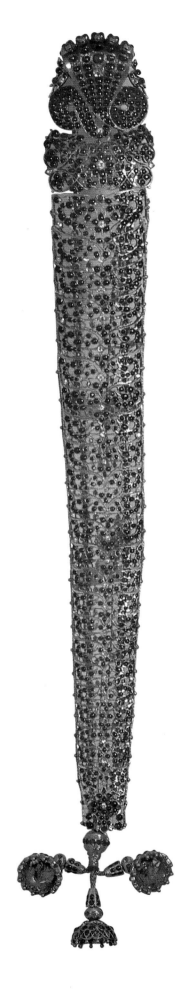

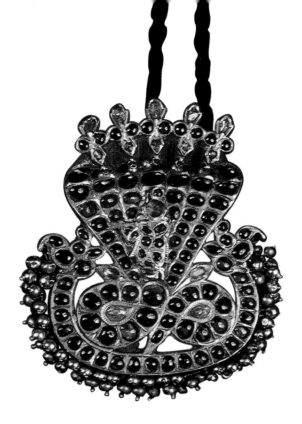

Above: **Head ornament.** *A braid or a 'jadanagam' showing Krishna dancing on the serpent Kalinga. Nineteenth century AD. South India.* National Museum, New Delhi, 89.992.

Left: **Snake-shaped Head ornament.** *Delicate workmanship with rubies, diamonds and emeralds on a braid. Nineteenth century AD. South India.* National Museum, New Delhi, 87.1156.

Facing page, above: **Head ornament.** *'Lalaat' and 'Sheersh alankar' (forehead and head ornaments) in three pieces; gold, studded with rubies and pearls. Eighteenth century AD. South India.* National Museum, New Delhi, 90.753/1-4.

Facing page, below: **Head ornament.** *A 'chudamani' in gold studded with precious stones. Seventeenth century AD. South India.* National Museum, New Delhi, 64.285.

girls before marriage. This custom is still current in some of the rural areas of south India.

The other type of ear-rings, common with the ladies of the Muslim communities of Kerala, are called *poottu* or lock. These are made of hollow gold sheets or other metal sheets soldered together. Each ear-ring consists of an angular hoop extending into a pyramidal form, and is finely worked in filigree designs. Unfortunately all these old ornaments are fast disappearing today, giving place to urban jewellery.

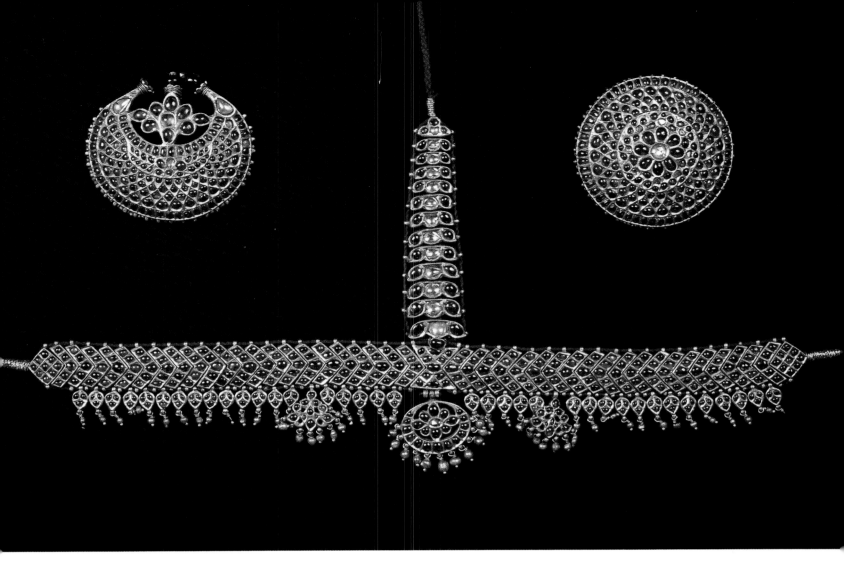

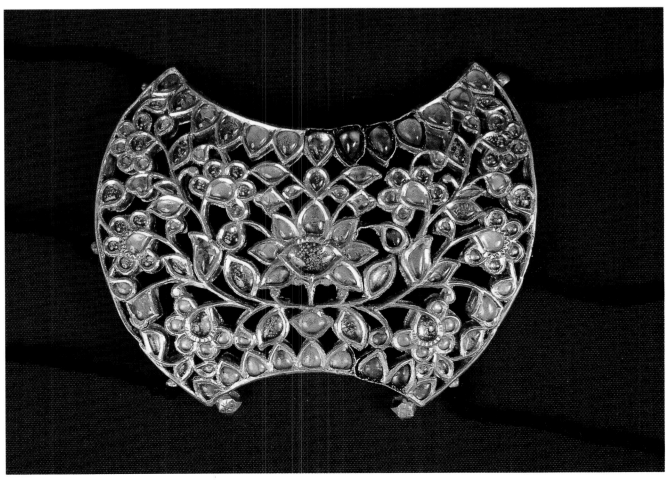

Tiger-claw pendant. *Gold studded with red stones. Early nineteenth century AD. South India.* National Museum, New Delhi, 94.47.

Ceremonial bangle. *Set with rubies and emeralds shaped in the form of a coiled snake with a lotus-shaped clasp. Nineteenth century AD. South India.* National Museum, New Delhi, 90.939.

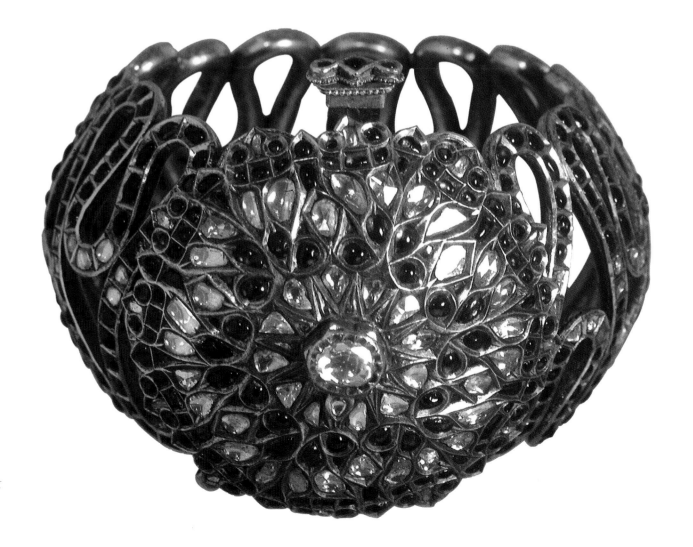

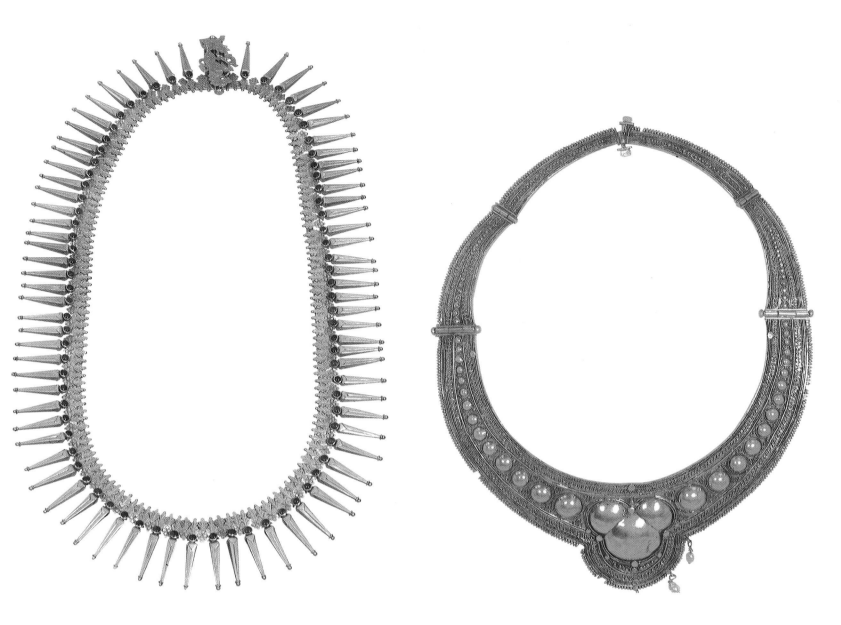

Necklace. A *'champakali' (jasmine bud)
necklace of gold studded with rubies and
beads shaped like jasmine flowers.
Nineteenth century AD. South India.*
National Museum, New Delhi, 94.50.

Necklace. *A part of temple jewellery.
Late nineteenth century AD. South India.*
National Museum, New Delhi, 94.46.

Bangle. *A 'kada' with intricate
patterns in gold.
Early twentieth century AD. South India.*
National Museum, New Delhi, 94.48.

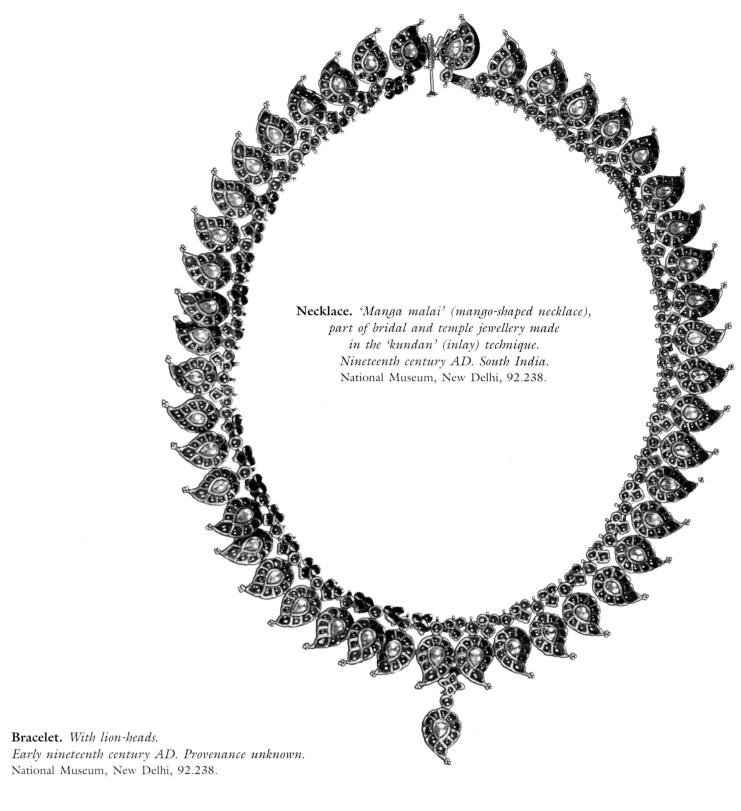

Necklace. *'Manga malai' (mango-shaped necklace),
part of bridal and temple jewellery made
in the 'kundan' (inlay) technique.
Nineteenth century AD. South India.*
National Museum, New Delhi, 92.238.

Bracelet. *With lion-heads.
Early nineteenth century AD. Provenance unknown.*
National Museum, New Delhi, 92.238.

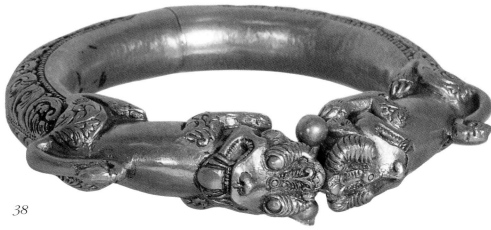

The Mughal Period

With the coming of the Mughals the lavish and gracious Persian culture began to rule court etiquette and norms. This ushered in a new era and opened wider horizons for the Indian craftsmen, who were passing through a period of depression and stagnation.

Although, no significant new forms seem to have been introduced in Indian jewellery, yet the craftsmanship improved considerably. The sophisticated taste and the generosity that the Mughal emperors were celebrated for made Indian jewellery famous and admired for centuries to come.

The armies of the Mughal empire overran almost all of India including the Deccan. For the first time, since the Mauryans, India was united under the firm control of one monarch. With political and economic stability ensured, the sophisticated taste of the Mughal rulers and their close relationship with the contemporary Persian monarchs together infused new vitality and vision in Indian craftsmanship. Thus, the superb draughtsmanship, controlled rhythmic linearism and the balanced colour-scheme of Persian art merged with the intricate forms and breathtaking chiselling of the Indian goldsmith. So, the significance of the Mughal dynasty's contribution to Indian jewellery lies not so much in its exquisite forms and amazing variety—which continued from the remote past—but in its embellishment and perfection. The accurate draughtsmanship in dealing with the decorative motifs and design, the perfect inlay of wires and the colourful enamelling over the glittering surface of gold made Mughal jewellery rare specimens of beauty and wonder. Apart from sublime treatment, the studding of precious gems emitting brilliant colours (which was the speciality of Indian jewellers) further enhanced the grandeur of the Mughal ornaments.

The grandest and most colourful of the Mughal emperors, Akbar took a personal interest in the fashioning of jewellery. His successors, particularly Jahangir and Shah Jahan, continued the Mughal tradition of love for precious stones and often had their names engraved on some of the quality gems. The ceaseless flow of European

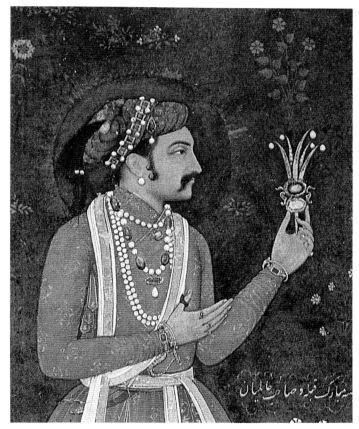

Detail of a Mughal miniature showing Shah Jahan as a prince examining a piece of jewellery. On his right hand, he is wearing an archer's thumb ring.
Seventeenth century AD.
V&A, London, 1M 14-1925.

Head ornament. *A turban ornament studded with rose-cut diamonds, a painted hexagonal emerald in the centre, two painted emeralds on the sides and six large emerald drops. Mid-nineteenth century AD. Provenance unknown.*
National Museum, New Delhi, 57.10/9.

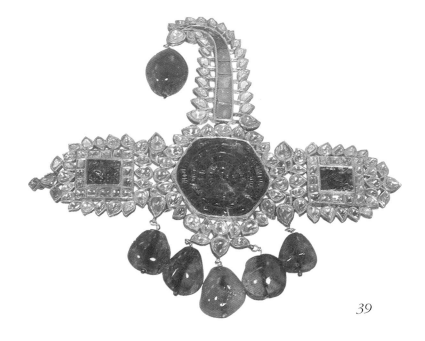

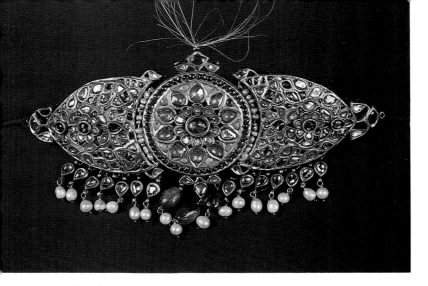

Head ornament. *A turban ornament with precious stones and pearls.*
Mughal period, eighteenth century AD.
Provenance unknown.
National Museum, New Delhi, 87.1150.

artifacts to the Mughal court, strong cultural and political ties with Iran and the regular employment of European artisans in the royal workshops—in the company of the local Hindu and Muslim craftsmen—provided an eclectic character to Mughal jewellery.

Jahangir, in his memoirs, mentions receiving fashionable European jewels through the governor of Surat (in the state of Gujarat), Muqarrab Khan. The European jewellers, such as Augustin of

Archer's thumb-ring. *Made of dark green nephrite with the legend in gold giving the date equivalent to 1631 AD and the title of Shah Jahan which he had adopted imitating his ancestor, Timur.*
Mughal period, seventeenth century AD.
Provenance unknown.
Salar Jung Museum, Hyderabad, XLIX/1338.

Bordeaux were known to have been in the service of the Mughal emperors. In fact Niccolas Manucci, a Venetian artillery expert and self-professed physician who stayed in India from 1656 to 1717 AD, wrote that as far back as the reign of Akbar, there were many Europeans working for the Mughals as 'lapidaries, enamellers, goldsmiths, surgeons and gunners.'

The characteristic feature of the Mughal jewellery of India is the beautiful enamelling at the back of the gold ornament; the front was set with uncut precious gems. Indians generally never allowed a gem to be spoiled by cutting, unless a flaw was to be removed. The Mughal jewellery exhibits the art of enamelling at its best. The delicately tiny and exquisite figures of birds, animals, trees, flowers and leaves in natural colours, enamelled at the back of an ornament, are as beautiful as a Mughal miniature painting. The purity of gold probably held the precious stone in its place and this is the reason that this particular technique was known as *kundan* work.

The noted ornaments of the Mughal era which are often found mentioned in contemporary chronicles are the necklaces, turban ornaments like *turra* and *sarpech*, armlets, bracelets (*dastband*), bangles, ear-rings and the archer's thumb rings. In addition to a variety of necklaces, turban ornaments were very popular among the Muslim rulers. While *turra* was used at the side of the turban, *sarpech* was fixed at the front. Traditionally consisting of jewels and feather plumes, the turban ornaments changed dramatically in design during the later period of Jahangir's rule when an adaptation of the European aigrette was introduced. Similarly, the jewelled armlets were modified after the European fashion during the 1620s and 1630s when diamonds, rows of pearls and two black beads, probably a dark coloured sapphire, were added to make it look like a brooch.

The most spectacular examples of Mughal jewels were fashioned out of carved Columbian emeralds; the dark green shade of the emerald went well with Islamic tradition. Jaipur was probably where this jewellery was fashioned. The most fashionable way of wearing emeralds was in the form of necklace pendants attached to a chain of Arabian pearls. At least one engraved diamond survives which is the centre piece of a jade and ruby pendant on a pearl necklace. This necklace, presently in a private collection in Switzerland, has a royal epithet which reads 'Shah Jahan, the

Emperor, the Religious Warrior'. It consists of two strands of pearls joined at intervals by ten red spinels, one of which is inscribed with the title of emperor Jahangir (Shah Jahan's father and predecessor) and the date in Hijra era (Muslim calender) equivalent to 1609 AD. The engraved diamond acts as the centre of a flower which has a stem of gold wire and leaves made of smaller diamonds. The engraving of gems with names and epithets of the rulers was in fact a tradition of the Timurid family (descendants of Timur the lame) which was followed by the Mughals in India.

Archer's thumb rings were originally designed for military use but those of the Mughal emperors are often decorative and ceremonial. The jade archer's thumb rings of Jahangir are still preserved in Bharat Kala Bhavan, Varanasi, whereas those of Shah Jahan are housed in the Victoria & Albert Museum, London and the Salar Jung Museum, Hyderabad.

Shah Jahan's successor Aurangzeb was quite orthodox in his views and hence did not approve of indulgence in gold jewellery due to Islamic injunctions. His court historian Mohammad Kazim, who wrote his memoirs *Alamgir Namah*, informs us that the emperor had even discarded the use of gold for making personal jewellery of the royal household. Instead, he preferred jade (*yashm*) for fashioning royal jewels. Precious stones like diamonds, rubies, emeralds and pearls were studded on the glossy surface of jade and the ornaments, thus fashioned, were deemed to be in conformity with the Islamic religious code.

Unfortunately very few original specimens of the personal jewellery of the Mughal emperors remain in India; most of them were carried off as loot by the foreign invaders, like Nadir Shah, and some of them can be seen even today in the collection of the Crown Jewels of Iran.

The *Ain-i-Akbari*, emperor Akbar's memoirs composed by Abul Fazl (the poet-general), provides a list of ornaments that women wore at that time. Similarly, other chronicles like *Akbar Namah*, *Tuzuk-i-Jahangiri*, *Shah Jahan Namah*, and the accounts left by European travellers further enrich the list of ornaments which formed a part of Mughal jewellery.

Archer's thumb-rings. *Made of jade, ivory and agate with gold inlay and studded with precious stones. Mughal period, seventeenth century AD. Provenance unknown.*
Salar Jung Museum, Hyderabad.

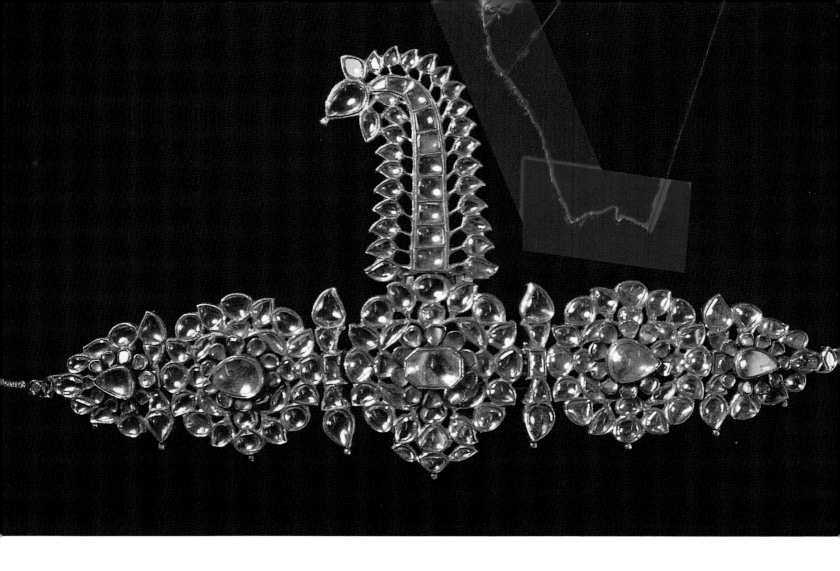

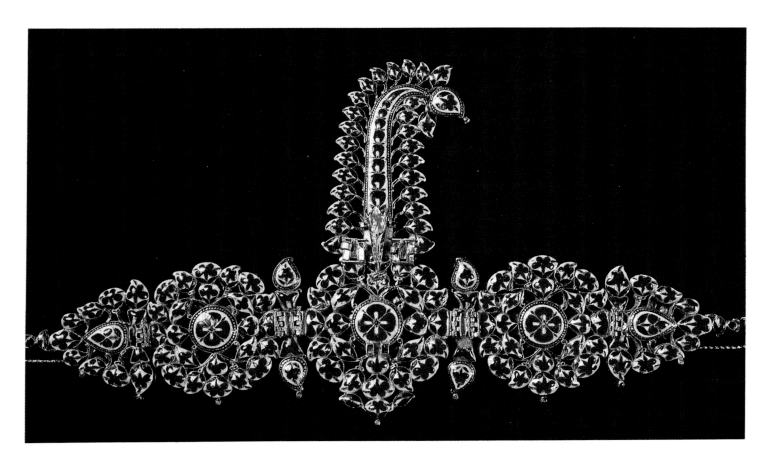

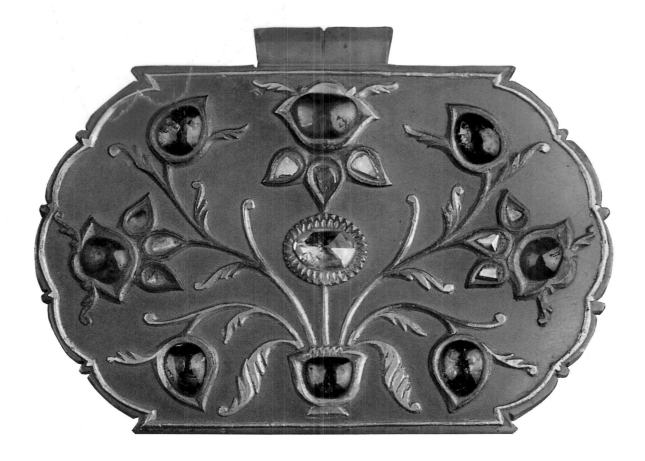

Jewellery for men:

Head Ornaments: A large number of male head ornaments are found mentioned in the literature of this period. The bejewelled crown *taj* was a jewelled aigrette to be worn on the turban. Shah Abbas of Persia had sent through his emissaries a *jigha* (a spray of gemstones worn at the front or side of a turban) studded with an engraved ruby and a *kalagi* (black heron's plumes with a pearl suspended at its tip, worn behind the *sarpech*) valued at that time at fifty thousand rupees, to Jahangir as a token of friendship. This set the trend for kings, and then nobles, to wear the *jigha* and *kalagi*. Another notable turban ornament was called *turra*. Prince Shah Jahan had presented a jewelled *turra* to his father Jahangir, when the latter visited him in Ahmedabad in the state of Gujarat. The *sarpech* and *sar-band* were

Facing page: **Head ornament.** *A turban ornament in gold and silver studded with diamonds and enamelled in red. Enamelling on the reverse is shown below. Mughal period, nineteenth century AD. Provenance unknown.* National Museum, New Delhi, 87.1166.

Jade pendant: *With gold inlay. The flowers are made of rubies and sapphires. The vase is of blue sapphire. Mughal period, early eighteenth century AD. Provenance unknown.* Salar Jung Museum, Hyderabad, XLIX/394.

Jade pendant. *With gold inlay representing floral motifs with eight leaves emerging from the centre having a big topaz shaped as a centre flower; the flowers on the eight sides are made of rubies. There is a gold border all around. Mughal period, seventeenth century AD. Provenance unknown.* Salar Jung Museum, Hyderabad, XLIX/387.

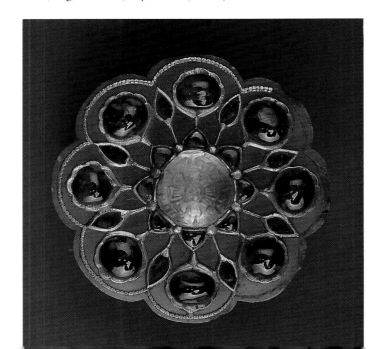

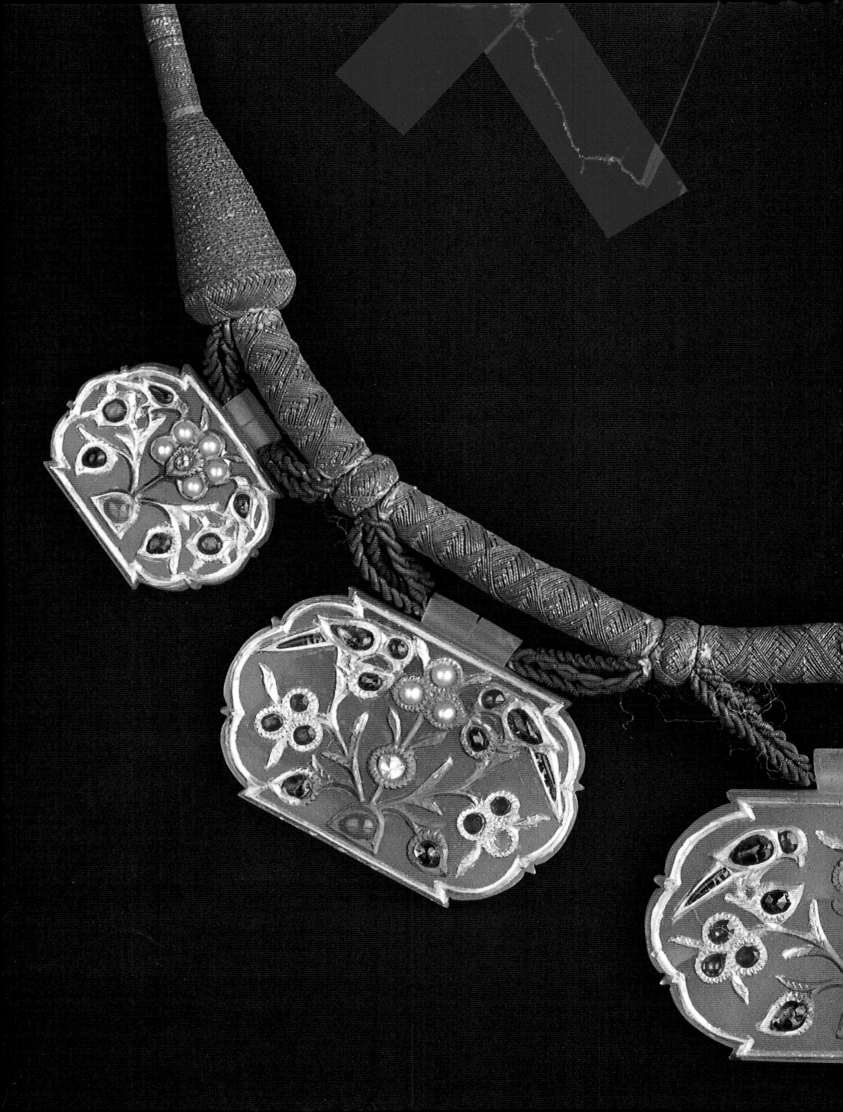

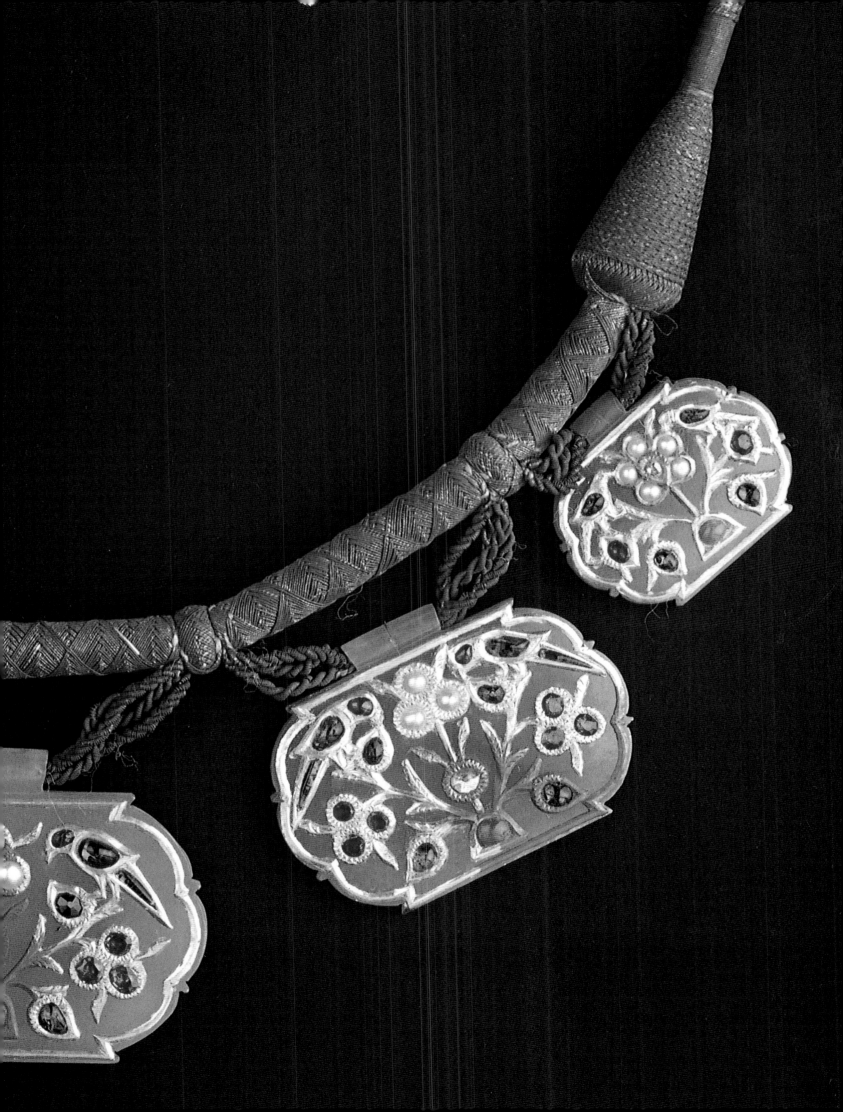

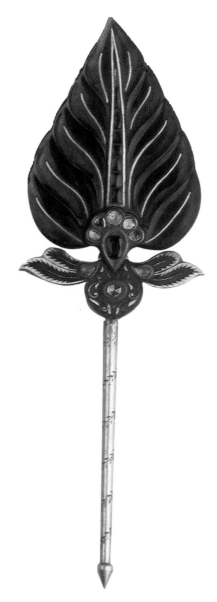

also placed on the turban. The *sarpech* was often studded with a tablet of gems in front. However, the *sar-band* seems to have been used by both men and women. The *sihra*, made of pearls and precious stones, was a special ornament worn on the head by the bridegroom at the time of wedding and was a common marriage present. The pearl strings of *sihra* covered the face of the bridegroom completely to avoid the evil eye.

Necklaces : A string of pearls, *mala*, was worn as a necklace. However, the jewelled necklace *urbasi* was most popular with the men from the Deccan, as mentioned by Jahangir himself in his *Tuzuk-i-Jahangiri*. The *gulu-avez* was a necklace made of rubies. The *baddni* was a long necklace hanging down to the waist.

Bangles and Bracelets : The *bazuband* was an armlet set with rubies and pearls. The *kara* was a massive bangle worn on the wrist and *pahunchis* were bracelets studded with costly gems.

Finger-rings : Finger-rings had become popular ornaments for men during the Mughal period. Interestingly they were sometimes made of a single precious stone. Costly gems were very often engraved with the names of the owner and then set on a finger-ring.

Jewellery for women:

Head Ornaments: Teeka, a jewel in the shape of a serpent, and *bindalee*, a round gold ornament, were worn on the forehead.

Ear Ornaments: The *khantehla*, probably a corruption of the word *kundala*, was a conical ear-ring. *Karanphul* was an ear-ring that

Jade turban ornament. *With gold staff having a leaf-shaped top made of sapphire. At the base of the leaf-shaped top are leaves and flowers made of rubies, diamonds and sapphires.*
Mughal period, eighteenth century AD.
Provenance unknown.
Salar Jung Museum, Hyderabad, XLIX/108.

Previous pages: **Necklace.** *With five jade pendants inlaid with gold to depict flowers and fruits. The flowers are made of rubies and the fruits are made of pearls. The two parrots on either side are plucking the fruits. The plants are springing out of vases made of coral.*
Mughal period, nineteenth century AD.
Provenance unknown.
Salar Jung Museum, Hyderabad, XLIX/453.

Jade pendant. *With gold inlay, showing a branch of a tree made of dark green sapphire with buds and flowers made of rubies.*
Mughal period, eighteenth century AD.
Provenance unknown.
Salar Jung Museum, Hyderabad, XLIX/206.

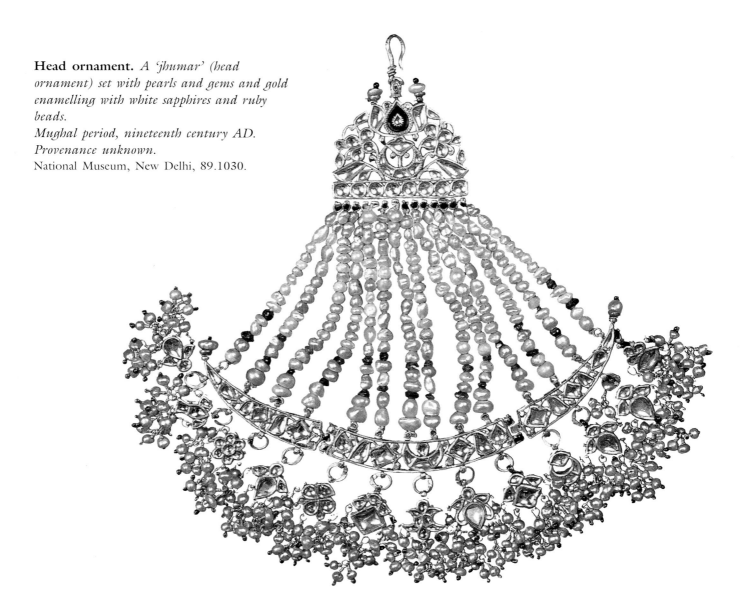

Head ornament. *A 'jhumar' (head ornament) set with pearls and gems and gold enamelling with white sapphires and ruby beads.*
Mughal period, nineteenth century AD. Provenance unknown.
National Museum, New Delhi, 89.1030.

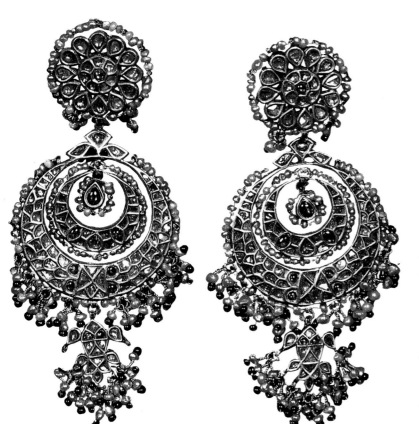

Ear ornaments. *Hoop ear-rings shaped like a double crescent with a fish motif and set with uncut diamonds. Early nineteenth century AD. Rajasthan.*
National Museum, New Delhi, 89.968/1-2.

resembled a rose. *Peepal putty* was a small crescent and nine or more of them were worn in each ear. The *ballee chumpakollee*, was a small flower shaped ear-ring worn on the earlobes. The *mourbhenevir*, another type of ear-ring was, charmingly, shaped like a peacock.

Nose Ornaments : It is during Akbar's period that we find mention of nose ornaments. The *phoolee* was a nose ring which resembled a rose bud with a stalk. The *lowang* was a golden clove shaped nose ring. *Natha* was a gold ring studded with a ruby and two pearls. *Beyser* was a kind of nose jewel, shaped as a flat crescent.

Necklaces : The *guluband* was a necklace consisting of five or seven strings of small rose shaped

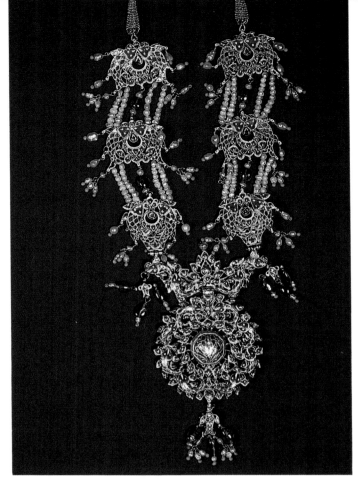

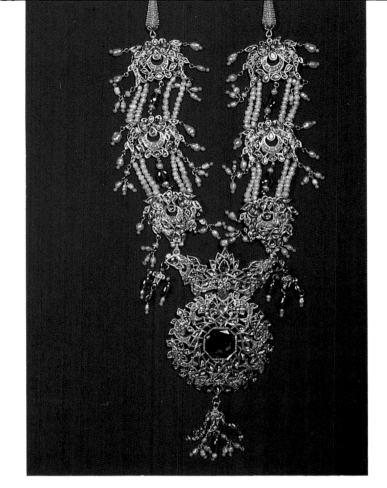

Necklace. *Set with spinels, pearls, turquoise, green glass and diamonds. The enamelling on the reverse is shown on the left. Mughal period, eighteenth century AD.*
Provenance unknown.
National Museum, New Delhi, 63.15/4.

Gold nose-ring. *Inlaid with semi-precious stones, decorated with copper and gold leaves on top and hung with chains and pearls.*
Nineteenth century AD. Himachal Pradesh.
National Museum, New Delhi, 87.1168.

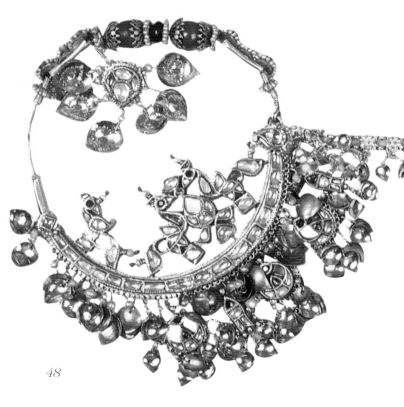

beads. A *har* was a string of pearls and golden flowers hanging from the neck. The *hans* was a collar made of gold.

Bangles, Bracelets and Finger-rings : The *bazuband* was an armlet. The *taar* or probably *tora* was a hollow ring worn around the arms. *Gujreh* was another variety of bracelet made of pearls and gold.

Girdles : The *katimekhala* was a gold belt worn around the waist. The *choodirghunta* (*chhudirghanta*) were small gold bells strung upon a silver wire worn around the waist.

Anklets : The *jeeher* consisted of three gold rings worn on each ankle. The *choore* were the two half circles made of gold, which were clasped round the leg. Similarly, the *doondnhee*, *mussowree* and *payil* were all anklets which had come in vogue at the time of Akbar. The *ghunghroo* were little gold bells strung on silk thread and worn around the ankles. The *baank* ornaments were meant for the top of the foot and were either square or triangular. The *beechheva* were toe rings made of gold. *Unwut* was a ring meant for the toe.

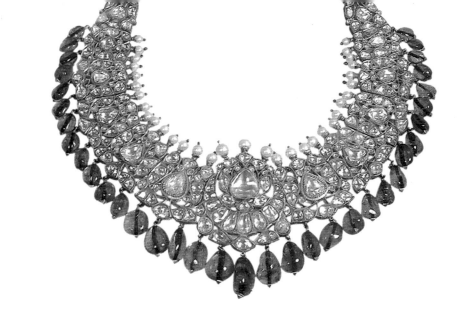

Necklace. *Crafted in 'kundan' (inlay) technique with diamonds, emeralds and pearls with enamelled backs.*
Early nineteenth century AD. Rajasthan.
National Museum, New Delhi, 90.940.

Necklace. *A 'hansuli' studded with painted rubies, emeralds and semi-precious stones and skirted with pearls. Enamelled in red, green, white and mauve.*
Mughal period, nineteenth century AD.
Provenance unknown.
National Museum, New Delhi, 62.638.

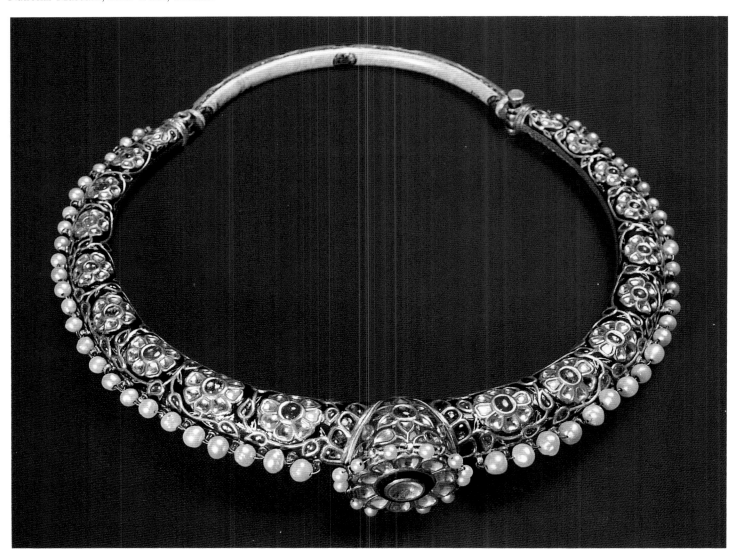

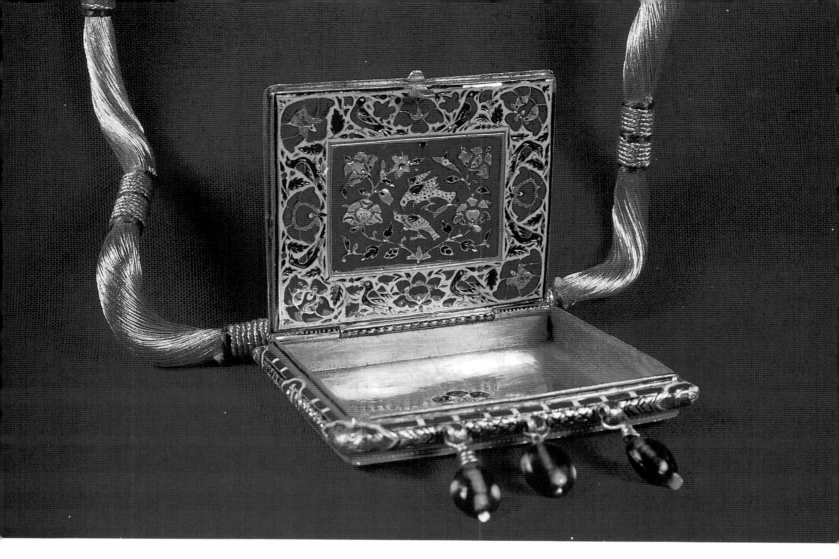

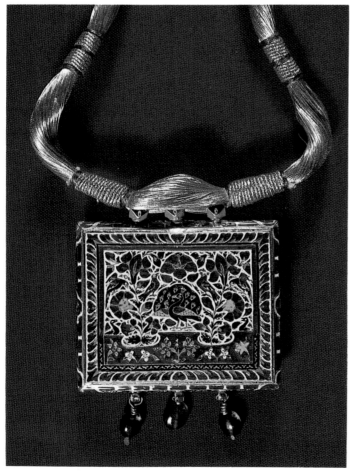

Gold armlet. *An amulet with the lid open showing space for protective and propitiatory messages. Enamelling on the reverse of the armlet is shown on the left. Set with white sapphires and 'navratan' (nine gems) consisting of emerald, diamond, pearl, ruby, yellow sapphire, coral, sapphire, cat's eye and zircon against red enamelled ground. Full-page detail of the front is on page 6.*
Mughal period, late eighteenth century AD.
Provenance unknown.
National Museum, New Delhi, 56.81/1.

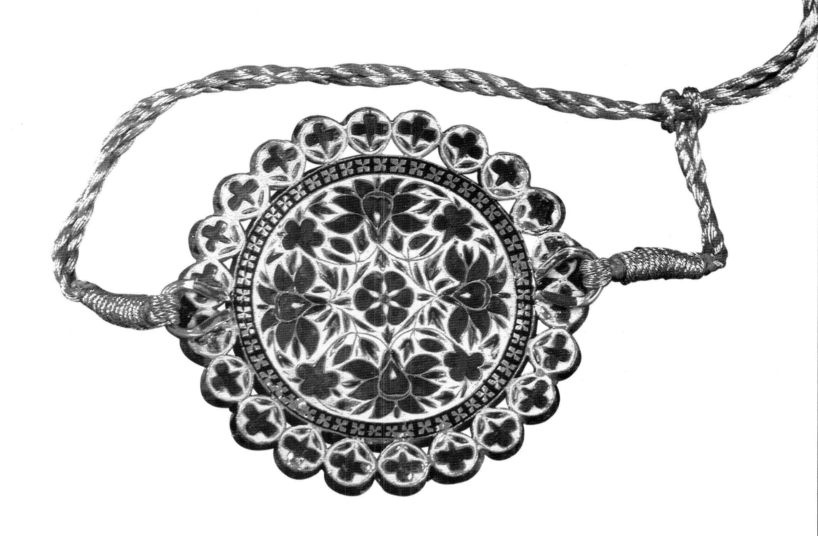

Above and below: **Armlet.** *The reverse depicting lotuses is shown above while the obverse is shown below with diamonds set on a green ground. Mughal period, eighteenth century AD. Rajasthan.*
National Museum, New Delhi, 57.105/9.

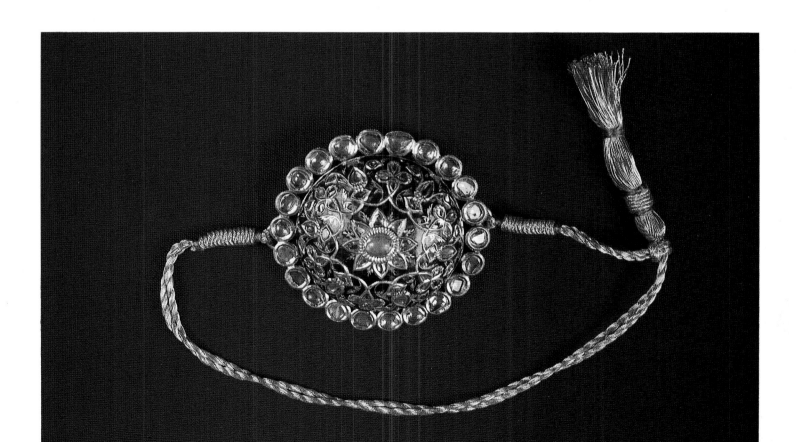

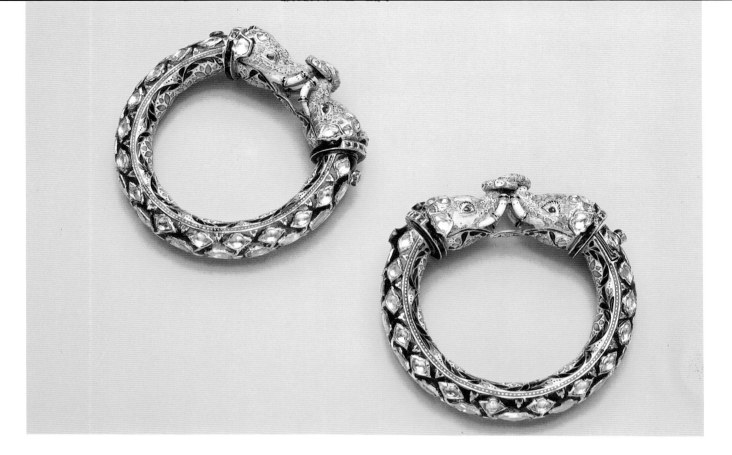

Above: **Gold bracelet.** *With pink enamelling and studded with precious stones.*
Late eighteenth century or early nineteenth century AD.
Varanasi.
Bharat Kala Bhavan, Varanasi, 3/10511.

Below: **Bangle.** *Set with semi-precious stones, painted emeralds and pearls on the outer rim. The inner side is enamelled in red, green, white and yellow.*
Nineteenth century AD. Rajasthan.
National Museum, New Delhi, 87.1180.

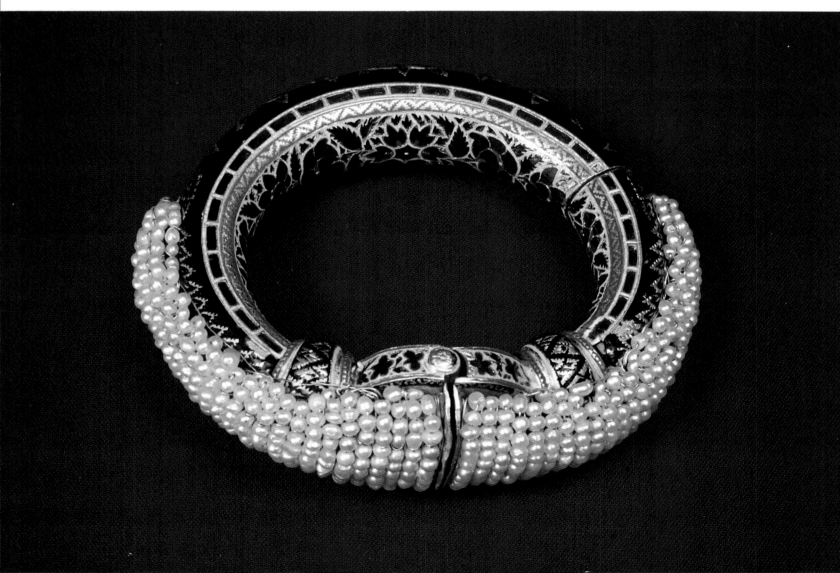

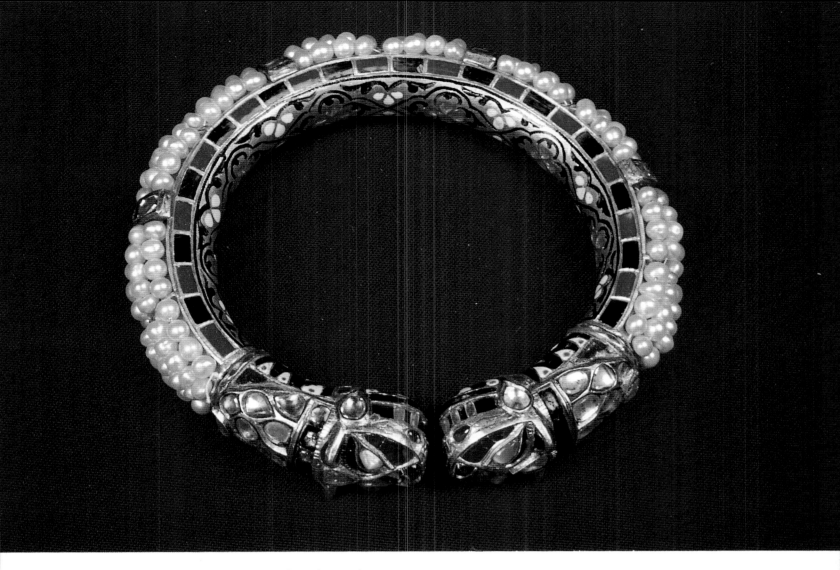

Above: **Bangle.** *Set with pearls, diamonds, rubies and*
enamelled on the back in red, white, green and gold.
Mughal period, eighteenth century AD.
Provenance unknown.
National Museum, New Delhi, 87.1167/1.

Below: **Gold anklet.** *With rubies, topaz and pearls,*
enamelled on the reverse.
Late nineteenth century AD. Rajasthan.
National Museum, New Delhi, 87.1179.

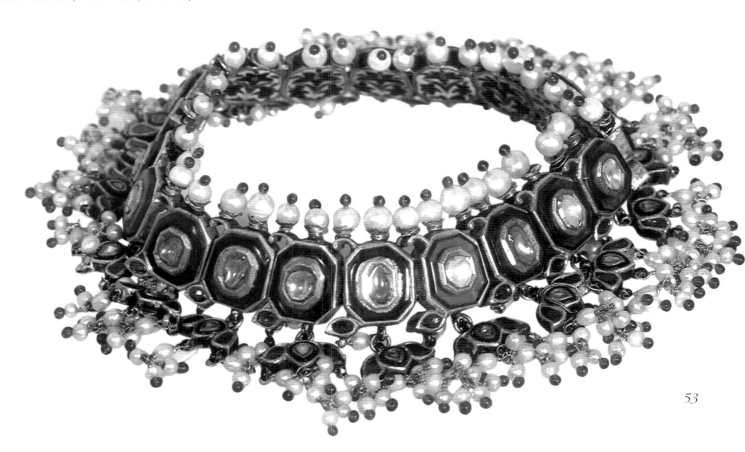

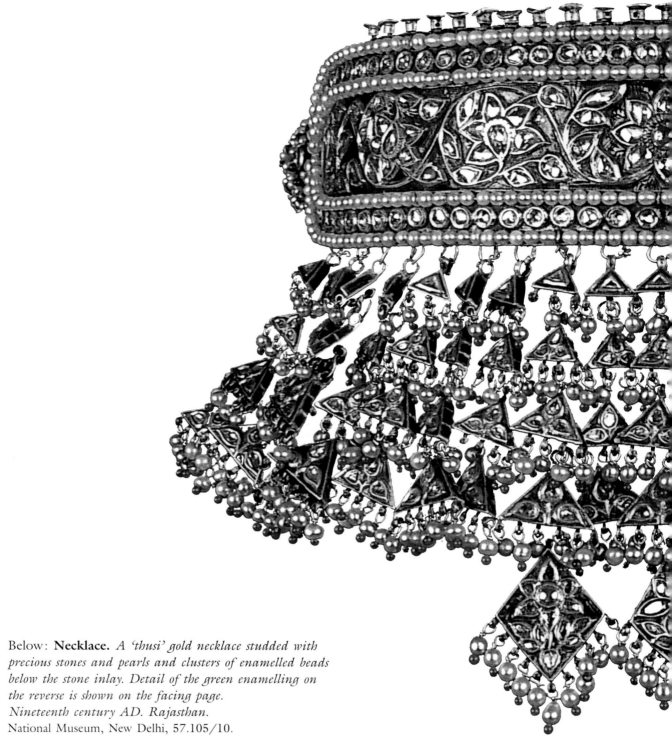

Below: **Necklace.** *A 'thusi' gold necklace studded with precious stones and pearls and clusters of enamelled beads below the stone inlay. Detail of the green enamelling on the reverse is shown on the facing page.*
Nineteenth century AD. Rajasthan.
National Museum, New Delhi, 57.105/10.

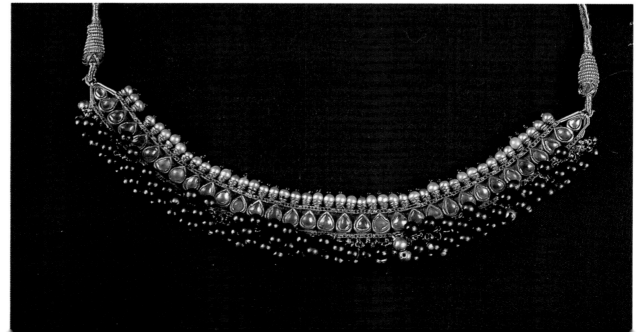

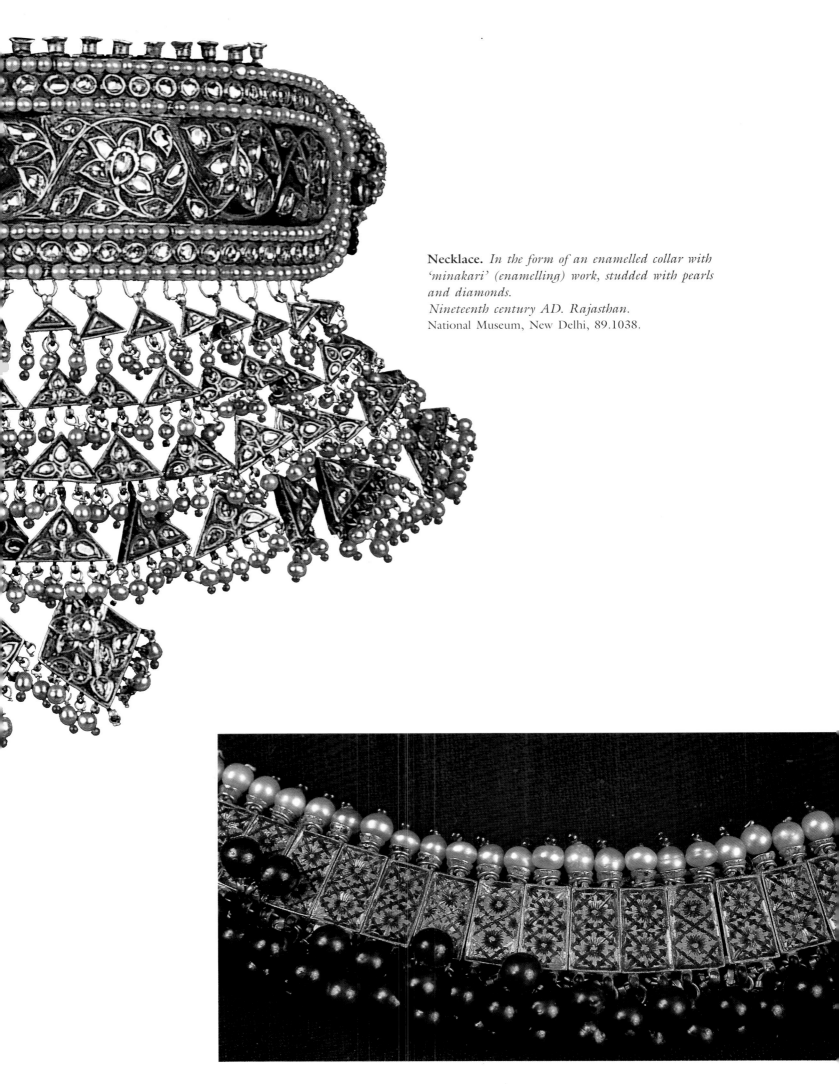

Necklace. *In the form of an enamelled collar with 'minakari' (enamelling) work, studded with pearls and diamonds.*
Nineteenth century AD. Rajasthan.
National Museum, New Delhi, 89.1038.

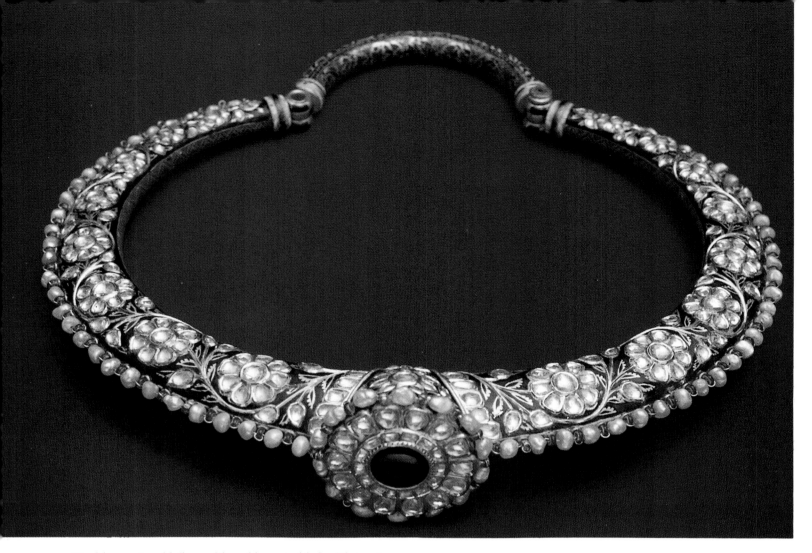

Necklace. *A gold 'hansuli' necklace studded with precious stones worn by men.*
Eighteenth century AD. Rajasthan.
National Museum, New Delhi, 88.195.

Necklace. *The enamelled reverse of a 'navratan' (nine gems) necklace with pearl skirting above.*
Mughal period, eighteenth century AD.
National Museum, New Delhi, 64.142

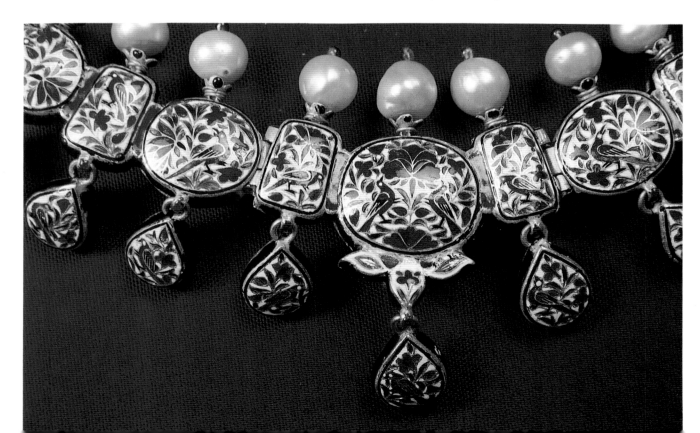

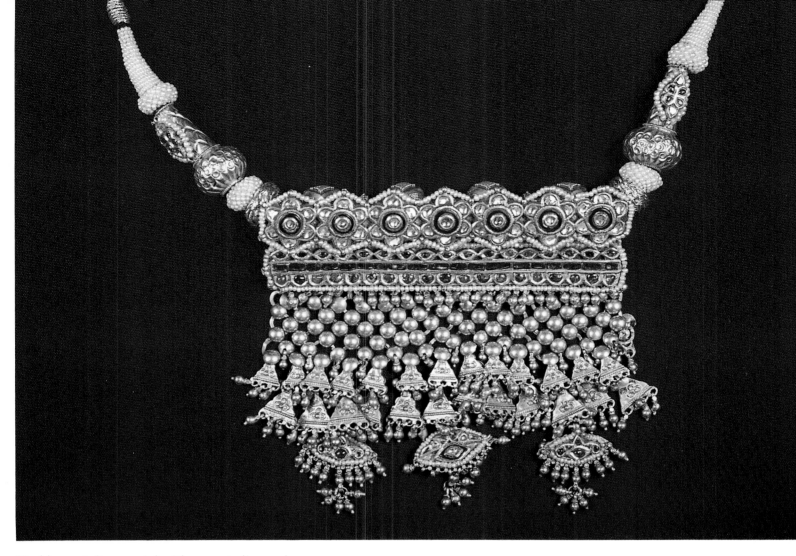

Necklace. *A 'tanmania' with rose-cut diamonds, rubies, emeralds and pearls.*
Nineteenth century AD. Rajasthan/Gujarat.
National Museum, New Delhi, 88.626.

Necklace. *A detail of the reverse side of a necklace with pearl skirting above and pearl droplets below.*
National Museum, New Delhi.

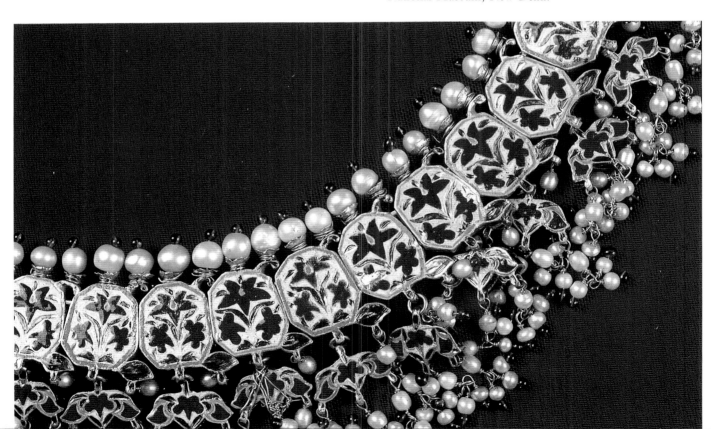

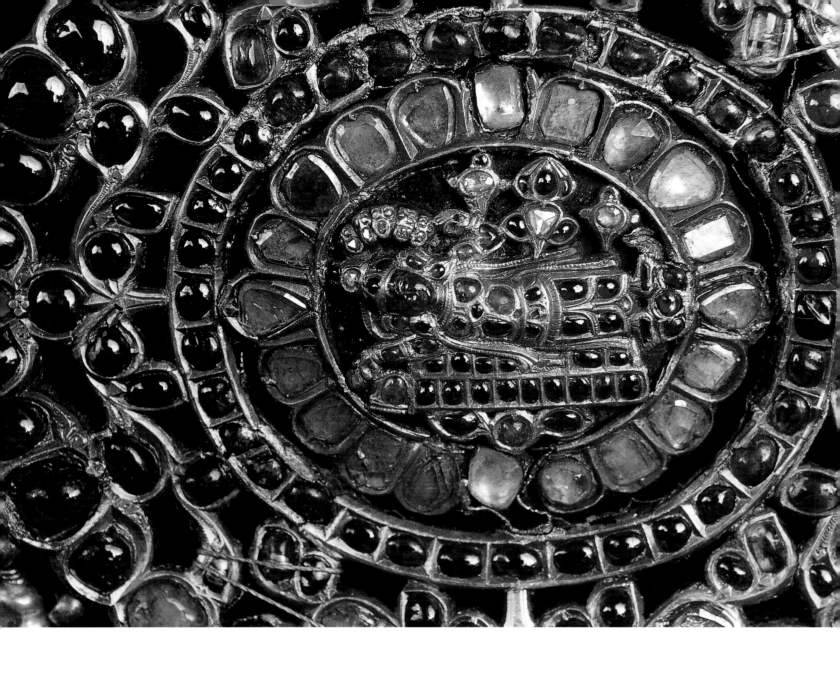

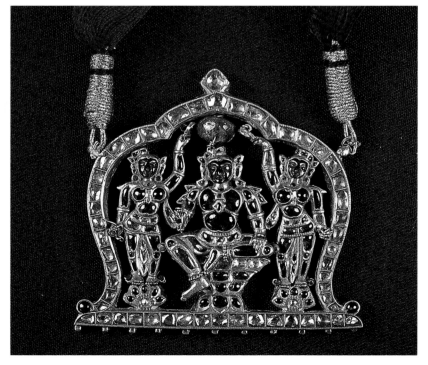

Pendant. *Part of the temple jewellery, studded with emeralds, rubies and diamonds, depicting Krishna flanked by his consorts Rukmini and Satyabhama.*
Eighteenth century AD. Tanjore, Tamil Nadu.
National Museum, New Delhi, 89.1014.

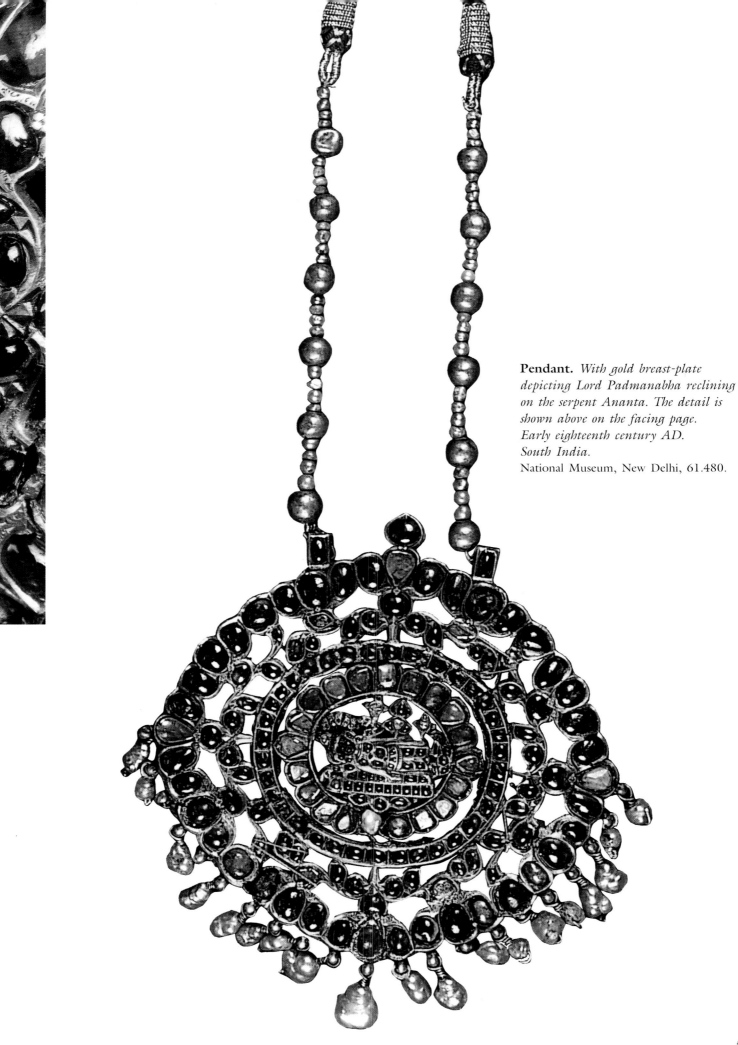

Pendant. *With gold breast-plate depicting Lord Padmanabha reclining on the serpent Ananta. The detail is shown above on the facing page. Early eighteenth century AD. South India.* National Museum, New Delhi, 61.480.

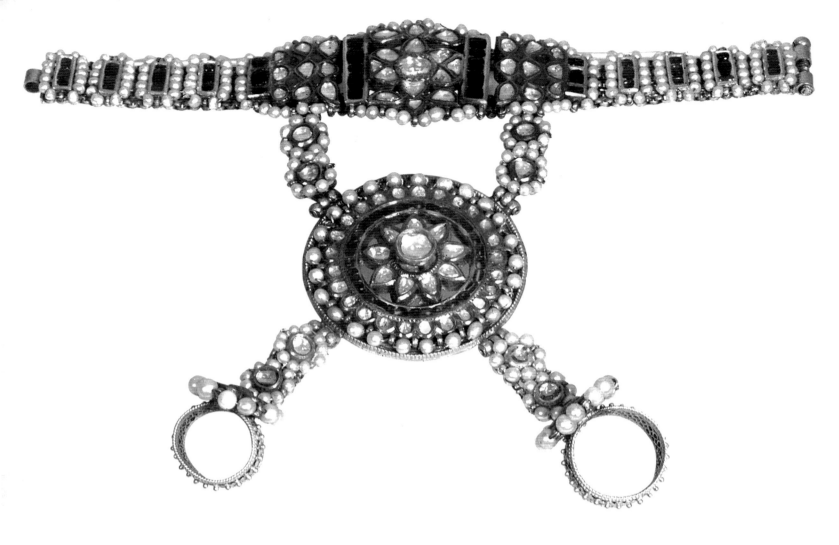

Bracelet. *With chains connecting to finger-rings in copper with diamonds and precious stones in floral motifs. Late nineteenth century AD. Rajasthan.*
National Museum, New Delhi, 90.495.

Armlet. *Carved in jade with a Quranic verse, the armlet is meant to be worn when setting out on a long journey. Mughal period, late nineteenth century AD. Provenance unknown.*
National Museum, New Delhi, 90.960/6.

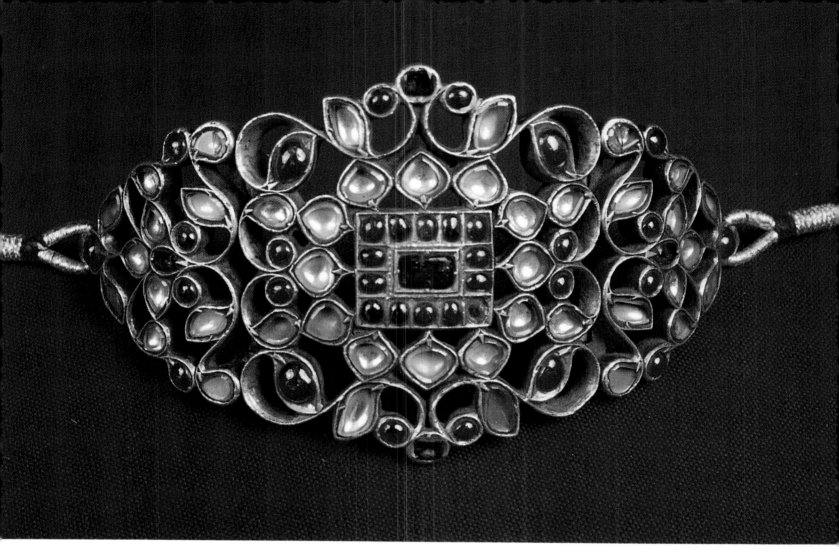

Armlet. *'Bajuband' (armlet) with open setting of rubies, diamonds and emeralds.*
Twentieth century AD. South India.
National Museum, New Delhi, 89.994/2.

Buckle. *A 'baksua' (buckle) studded with diamonds, rubies and emeralds.*
Early eighteenth century AD. Rajasthan.
National Museum, New Delhi, 87.1182.

Armlet. *With rubies and diamonds.*
Late nineteenth century AD. South India.
National Museum, New Delhi, 89.991.

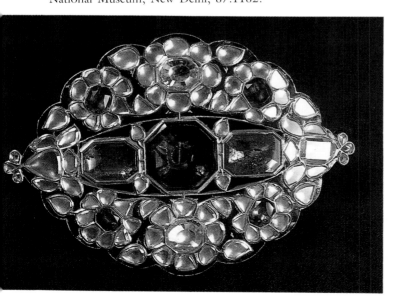

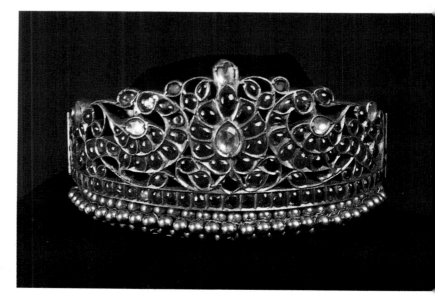

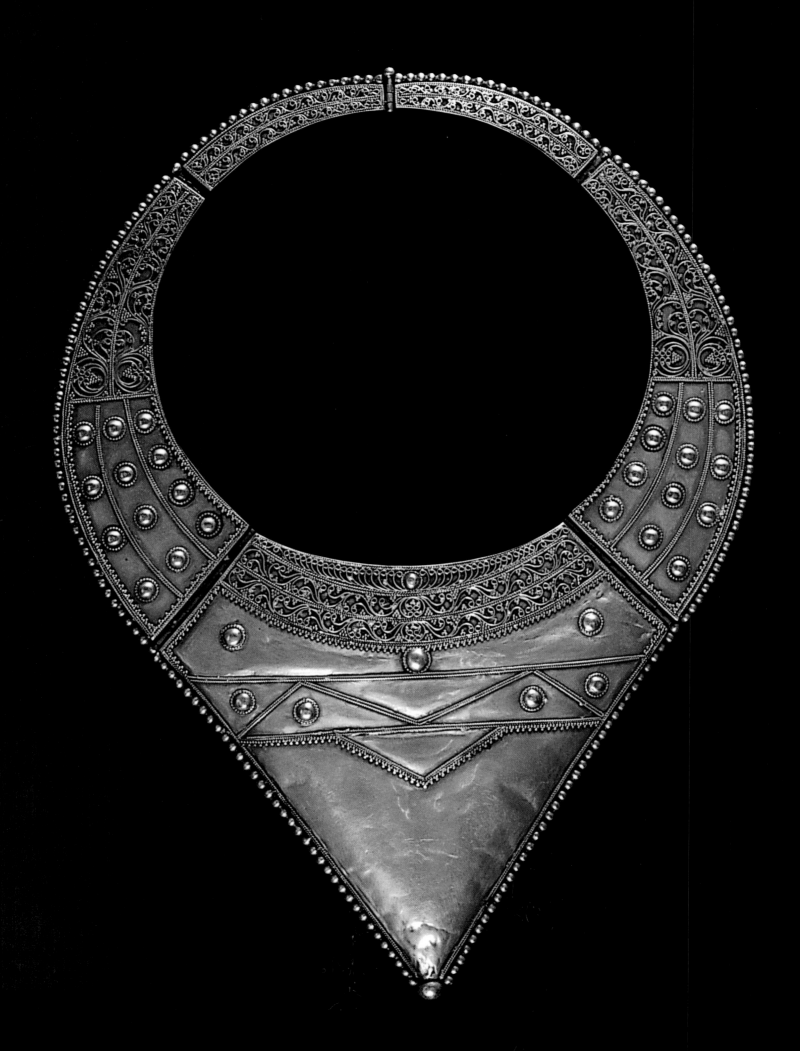

Temple Jewellery of South India

The theory of re-incarnation of the Hindu gods and goddesses in anthropomorphic form was probably the reason why the practice of offering costly gems and jewellery to the divinity in Indian temples started. The gods and goddesses are offered a variety costumes and ornaments, which are strictly according to canonical injunctions. For example, the costumes and ornaments offered by a Shaivite (followers of Lord Shiva, of the the Hindu Trinity) will differ from those offered by the Vaishnavites (followers of Lord Vishnu of the Hindu Trinity). The ornaments, such as crowns and other jewels, also vary from god to god as per the iconographic texts. Hence, the offering to a deity is prepared in consultation with the *acharyas* (Gurus) who are conversant with the existing iconographic codes and traditions relating to each sect. The ornaments could be made of precious gems, gold, silver, copper, and so on—depending upon the economic status of the donor.

Facing page: **Necklace.** *Designed with a thin gold wire, part of temple jewellery.*
Eighteenth century AD. South India.
National Museum, New Delhi, 90.754.

Ear pendants. *Set with cabochon rubies, part of temple jewellery.*
Nineteenth century AD. Provenance unknown.
National Museum, New Delhi, 89.1016/1-2.

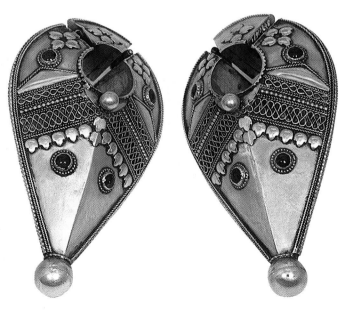

Thus the temple jewellery, as the term denotes, consists of ornaments specially found in the collection of various temples of the country, either donated or made according to specifications to adorn the deities. The items of temple jewellery are better preserved in south Indian temples as compared to those of the north which have been often subjected to foreign invasions. Such jewels and jewellery specimens have a marked difference as and when compared to other categories of ornaments in terms of their functions and use. The temple jewellery exhibits an amazing similarity with those of the temple sculptures. The temple-jewellery was prepared by trained artisans working in temple-workshops. The Mysore ruler, Krishnaraja Wodeyar III had set up a special workshop for jewellers of excellence to make exclusive jewels which were offered to major temples of south India. Most of these jewels and other ojects donated by him and his queens bear inscriptions giving dates, events and the offerings made and so also their weights, measurements and even the estimated value.

The jewels offered in a Saivite temple can be divided into two broad categories: those offered to the main Siva-linga (the phallic representation of Lord Shiva) and those offered to the subsidary gods and goddesses. For instance, the top of Siva-linga should not be kept empty during the time of the *abhisheka* (ritual bath) ceremony and the *mudi* or crown should always be placed on the top.

The main Siva-linga is adorned with several very costly jewels, like necklaces, bracelets, armlets, bangles, rings and other ornaments. The costliest and most valuable jewels carry several thousand pearls in them. One Virapatta was made with 343 *kalanju* of gold and carried thirteen thousand, three hundred and twenty eight pearls, ten diamonds and sixty-four corals, Another *Pattika* was made of eight hundred and three *kalanju* of gold, five thousand, six hundred and eleven pearls and fifty-seven corals. Its price is mentioned in the temple records as two thousand *kasus*.

In the days gone by, the best and costliest gems and jewellery were offered to gods and goddesses by the kings and nobles as *Sripad*

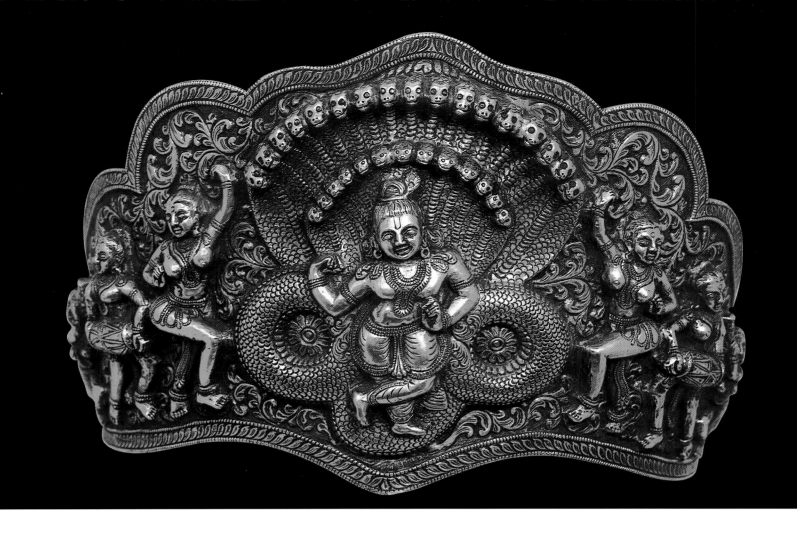

Crown. *Showing Krishna killing the dreaded snake Kalinga; part of temple jewellery; an example of repousse technique.*
Nineteenth century AD. South India.
National Museum, New Delhi, 9449.

pushpa (flowers to the holy feet of the Lord) on special occasions. There is ample epigraphic evidence available in the ancient temples of Tamil Nadu and Karnataka, eulogising such pious gifts.

The temples of Tamil Nadu during the reign of the Chola dynasty played a dynamic role in contributing to the growth of art of jewel making. In fact, the temples of south India maintained their own workshops, employed skilled goldsmiths and jewellers to fashion jewels, to test and evaluate them when necessary. The temples not only employed the master craftsmen but also conferred royal titles on them for their mastery and excellence in the art.

Although the jewels of the Chola period have not survived yet a detailed description of the Chola jewellery can be found in the inscriptions of the King Rajaraja Chola at Tanjore. This information provides an interesting insight into the degree of sophistication attained in the art of jewellery during the Chola period.

The Madurai temple still preserves very valuable and costly jewellery, especially the crowns made of gold and studded with the nine gems, *navaratna*. The most significant of them is the golden, jewelled turban, Ratnachurmmandu, which is worn on one of the festivals by Lord Sundaresvara, who is supposed to have worked as a casual labourer and carried the earth on his head on behalf of an old lady.

The heights of pomp and lavishness in offerings to deities were scaled during the rule of Vijayanagar kings, particularly in the reign of the colourful Krishnadevaraya. A number of the inscriptions found in the temples built in his reign mention costly gifts of jewels to various deities. The most important gifts given by Krishnadevaraya were to Lord Venkatesvara, the presiding deity of the celebrated temple at Thirupati which he visited seven times. He is said to have presented a *navaratna kirita*, made of around fifteen hundred and two *pon* (a measure of gold), one thousand eighty *kuntala*, three thousand red stones and two-hundred emeralds in the year 1513 AD. He had also performed *Mahadana*, (Major offering) consisting of sixteen other great gifts, such as *ratnadhenu*, a cow made of precious stones, *hiranyasvaraths*, a chariot with

golden elephants and several other objects made of solid gold.

Yet, the most precious offering made by him was that of a *Navaratna Prabhavali-Makara Torana* on February 17, 1512 AD. It was made of around twenty-eight thousand *pon* of gold, fourteen thousand *vommaccu pon* (measure of type of gold), eight thousand solid gold pieces, eleven thousand red stones, four thousand pearls, besides other precious gems. The total number of gems used in this *prabhavali* (necklace) was fourteen thousand seven hundred and eleven. In order to commemorate this event, he issued a special gold coin, called *Dodda Varahan* or the double Varahan, which was depicted with the necklace and an effigy of Lord Venkatesvara.

Even the Muslim rulers of the south like Hyder Ali and Tipu Sultan of Mysore and the Nizam of Hyderabad donated lavishly to temples.

There is an interesting account about the offering of an emerald necklace known as *Tipu's Pachche Haar* by Tipu Sultan to Srikanthesvara temple, Nanjanagudu near Mysore. It is said that Tipu Sultan's favourite elephant had once fallen ill beyond the hope of recovery. Tipu was then advised to offer prayers to Lord Nanjundesvara to restore the health of the sick elephant. As a result of Tipu's prayer to the Lord, the ailing animal was miraculously cured. Moved by this Tipu decided to offer one of his choicest possessions to God. He visited the temple and offered this precious emerald necklace. Even today, regular worship is offered to Pachche Siva-linga, also known as *Hakima Nanjunda* or the Physician God. This particular necklace is worn by the deity only at the time of *Girijakalyana* or the marriage ceremony to the god's consort, Parvati.

The gift of precious gems and jewellery offered by Kokamahadevi, queen of Rajaraja, to the temple at Thiruvaiyaru is also of great significance and worth mentioning here. The practice of offering gems and jewellery to the temples appears to have continued even by the rulers of the subsequent dynasties. The later Pandayas also made a number of such pious fifts to various temples at Madurai, Srirangam and Chidambram, etc. in the thirteenth century AD.

However, the majority of the exsisting gems in south Indian temples today are datable to the Nayaka period. Several of the Nayaka rulers, like Thirumalai Nayaka of Madurai, Raghunatha Nayaka and Vijayaraghava; the queen Mangammal and Vijaya Ranga Chokkanatha Nayaka of Madurai took an active interest in building new temples, reforming their administration, re-organising the festivals and offering fabulous gems and jewellery to various gods and goddesses and in the names of the famous saints of Tamil Nadu; for instance the Chitrai festival was organised at the temples of goddess Meenakshi and Lord Alagar of Alagar Koil. Many of their presents are still used at Madurai and Alagarkoil.

The finest of gems and jewellery of the Nayaka period can still be seen in temples like Mannargudi, Nachchiyarkoil etc, of Thanjavur district. The jewel collection of the Srirangam temple is of great historical significance. Many of the jewels housed there bear inscriptions of their donors, mainly the later Nayakas of Madurai, such as Vijaya Ranga Chokkanatha Nayaka and his queens Minakshi and Krishnamma. Besides jewels, there are a number of other costly items made of gold, such as a gold palaquin, known as Tolukku Iniyan, golden umbrellas, vessels, staff, etc. which were also gifted to the temple. Another very significant gift of a stone pendant bearing the name of the Maharatta ruler Sarfoji of Thanjavur is also preserved in the Srirangam temple. The high excellence and intricate workmanship of the art of jewellery of the Nayaka period can still be seen through these fabulous jewels housed in the temples of Tamil Nadu.

Although the temple jewels have retained their ancient forms yet, the outer influences from far off lands, particularly from the Mughal court, did not fail to bring change. The shape of crowns and necklaces had started changing to the tune of Islamic traditions with the passage of time. For example, the conical *Kullah*, a golden cap of the Mughal court is introduced during the Nayaka period. Similarly one of the crowns gifted by Thirumalai Nayaka is called 'Mughal Mudi', a name given after the Mughal tradition.

Most of the precious ornaments studded with fabulous jewels, which are housed in various temples are the gifts of Raja Krishnaraja Wadeyar III of Mysore. A Gandabherunda Padaka (pendant), now in Cheluvanarayana Swamy temple, Melkote, was offered by him. Similarly, the Ramapattabhisheka pendant was also offered by Krishnaraja Wadeyar. This was possibly the golden era for fashioning the most intricate and fabulous classical jewellery of South India.

A number of figurative representations of various gods and goddesses on gold pendants are also found donated by the devotees to various

temples in Mysore. A gold pendant depicting the figure of Sri Vitthala, another form of Lord Krishna, is presently housed in the Panduranga temple of Pandarapura in Maharashtra where the god is shown standing inside an arch. The border of the pendant is decked with *navaratna* stones.

Besides the necklaces with heavy pendants studded with costly jewels, there are chain of coins (*Kasina Sara*), Kadagas (bracelets), *Kankanas* (wristlets), *Gejjevanki* (armlets), Waist bands, (*Gejje Odyana*), *Tali* (mangalasutra) and various types of head-gears (*Kirita-Mukutas*). There are a variety of ornaments attached to various parts of the body, such as the *Mukha Kirita* (masks), *Karnapatra* for ears, (*Chandrabottu* or *Surajabottu*), *Abhaya* and *varada hastas* and *Padmapithas*, studded with glittering gems which were offered by kings and queens from time to time, now housed in the various temples of Karnataka.

In spite of alien influences slowly affecting the shapes and sizes of temple jewellery, the goldsmiths of south India successfully retained their identity to a large extent. Their motifs and designs are mostly traditional. For example, a recurring motif among the jewel pendants is a double-headed eagle, called Gandabherunda, which was earlier the royal insignia of the Hoysala rulers. This particular motif was retained in south Indian jewellery till the Nayaka period. The designs of ornaments are mostly organic, named after the local flowers and birds. For instance, the names of several motifs are such as *tamarappu* (lotus flower) *kallippu*, *nerinchippu* represent flowers. A few designs are also named after birds and animals, like *kokku* (crane) *tavalai* (frog) *amai* (turtle) *makara* (crocodile) and *kimpuri*, etc. The *mangay* (mango) motif is also very common.

Strict measures were adopted to preserve and protect the temple-treasures. The rules were codified to provide guidelines to temple authorities. An ancient manuscript, *Talapustaka*, datable to the seventeenth century AD refers to the procedure prescribed for the protection of temple-jewels and for fixing responsibility on the officials connected with this work. The two responsible officials, Kaivistari and Kaiyatchri were held responsible; the former would receive jewels on festive days and would return them to the latter immediately after their use for depositing them in the treasury. The jewels were properly checked and kept under lock and seal by the third officer, Mudradhikari. During the period when the jewels were issued and taken out in procession adorning the deity, the temple guards called Meykaval would keep a watch over them.

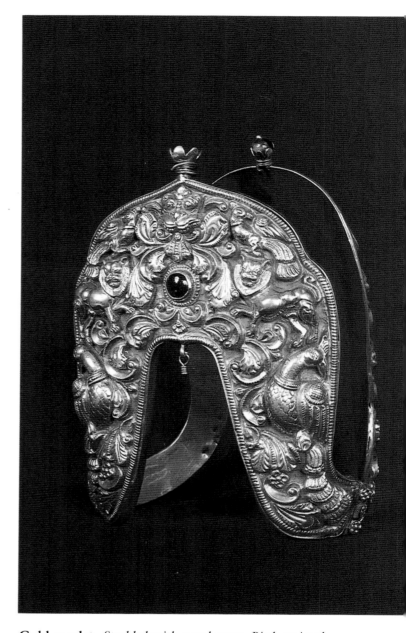

Gold armlet. *Studded with a red stone. Bird, animal and floral motifs crowd the gold ornament. Early eighteenth century AD. South India.* National Museum, New Delhi, 92.247.

Tribal Jewellery

While society for centuries has worn ornaments to look more attractive, the tribals wear them for very different socio-religious reasons. The symbolic value of the ornament is much more important than its material cost. All societies have used symbols down the ages: the interesting thing is to decipher what they mean, not how they may have originated. For example, the long tail feathers of a hornbill are a part of the ceremonial or ritual dress for all the *Naga* tribes of the state of Nagaland in northeastern India. It indicates high status in society. Similarly the boar's tusk is an ornament which is considered the insignia of a warrior. It is worn variously as a necklace, on a helmet, through the earlobe, and so on.

It is not so much the aesthetic quality for which an ornament is valued. It is sometimes more like the sentimental value attached to certain ornaments, as they are passed on from father to son or mother to daughter and are regarded as family heirlooms; hence they cannot be parted with at any cost. Social identity and status were, to some extent, hereditary but they could also be won and acquired through one's martial character and acts of personal valour, like beheading an enemy, the killing of a boar or a tiger and so on.

The *Nagas* of northeastern India use mostly materials like feathers, teeth, horns, shells, tusks, wood, and so on to fashion their ornaments. A majority of the ornaments are also supposed to have hidden meanings and power. For example, the *Lhota* man, who wears a boar's tusk, does not procure it himself, but through an intermediary who will attract to himself any evil that may be contained in them. Similarly, a *Sema* warrior may not wear the tusk of a boar he has himself killed, even if he is entitled to this ornament. The *Angami* man entitled to wear hornbill feathers may not do so in the period between sowing the millet and harvesting the rice.

Ornaments are also used for the purpose of identification among tribes. Sometimes the same ornament is used in a different manner by different units. For instance, the member of *Rengama* and *Lhota* units wear the classic 'enemy's teeth' ornament, which is a flat piece of wood, about one foot long, representing the head of an enemy with cowries for the teeth, red cane for tongue and a fringe of red hair for blood pouring out of the mouth. It is an ornament of the warrior which the *Angamis* wear on the chest, and the *Sema* on the chest or on the back.

The use of a particular ornament might be restricted in the case of the more hierarchical communities; in which case it can be fought over and worn even by a member of another unit striving for a higher status. The ornaments of the *Nagas*, therefore, reflect the identity of a particular *Naga* community as it exists in a particular moment, and also acts as a means to change it, by encouraging individuals to strive for a higher status.

The ornaments of *Padam-Minyong* tribes of Shillong of northeast India are equally interesting. Earlier known as *Abor*, these people now prefer to call themselves *Adis*. The women wear heavy yellow necklaces, iron copper bracelets and peculiar ear-rings which are made of long spirals of wire about two inches thick so that they dangle down to their shoulders. The men wear a necklace composed of blue stones strung together—it is hereditary, passed on from father to son, and is highly valued. The women embellish their arms, from the wrist to elbow, with brass rings.

The most popular ornament, *beyop*—a girdle worn by every girl and woman until the birth of her first child—consists of locally made discs fastened on to a band of cane, crew pine or a strip of hide. After the birth of the first child, it is discarded and the women wear belts of cane which they weave for themselves.

Ashing women and men wear large ear-rings with three stones set on a base in the front, from this base hang strings of beads down the sides of the neck ending in a pair of tassels of red cotton wool. The northern *Padam* and *Minyong* women wear a very elaborate type of ear ornament which is a spiral of six to seven coils of silver to be worn in the earlobe.

Apart from the jewellery of the northeast, the tribal jewellery from other areas like Madhya Pradesh, Gujarat, Orissa, Arunachal Pradesh, West Bengal, Manipur and some regions of Andhra Pradesh and Rajasthan are equally famous.

Mannequin wearing perforated conchshell ear-rings and three different types of necklaces.
Twentieth century AD. Nagaland.
National Museum, New Delhi.

Headgear. *A Naga cheiftain's ceremonial headgear made of cane backed with cloth and decorated with seeds and hornbill feathers.*
Twentieth century AD. Nagaland.
National Museum, New Delhi, 90.809.

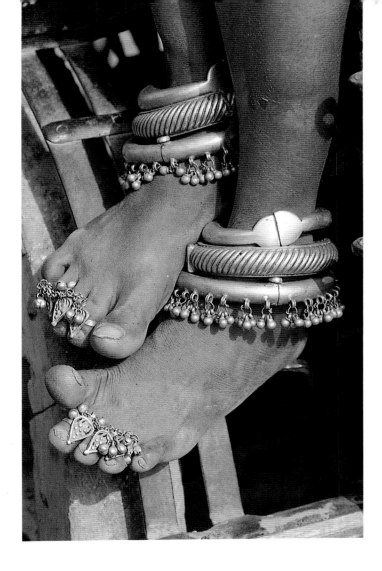

Anklets and toe-rings. *Silver anklets and toe-rings skirted with bells.*
Twentieth century AD. Rajasthan.

Bihar and the *Marias* and *Madias* of Madhya Pradesh.

Tribals believe that ornaments made of iron create magic. For example, iron rings are worn as protection against lightning. Iron neckbands are used to ward off the evil effects of witchcraft. Similarly, iron hairpins are worn as a cure for headache and a cowrie is worn as an amulet to ward off the evil eye.

Now coming to the tribes of the other regions in the country, silver jewellery appears to be very popular among the regions of south Gujarat. In Jaipur, Rajasthani tribal married women wear solid silver necklaces. In Nalgond, Andhra Pradesh, silver necklaces, waist belts, anklets and forehead ornaments are designed in different shapes and patterns. These are mostly worn by the women of the *Lambadi* tribe that inhabits this area.

The *Dangis* of Gujarat use ornaments; tattoo and paint their bodies and pierce their earlobes and nostrils. They also wear leaves, flowers and feathers to decorate themselves. No doubt, there appears a gradual change in the materials, forms and techniques used in fashioning their jewellery with the passage of time. The modern *Dangi* women go for a mass of silver ornaments; brass and iron ornaments are seldom used nowadays.

Of all the ornaments of a *Dangi* woman the nose ring, known as the *natha*, is most important—it is a round gold ring bigger than an Indian rupee coin in size.

Another rare but interesting ornament is the *dangi-kap*, a silver necklace in double chain with forty-eight small silver bell pendants. The *Warlis* and *Bhils* of Gujarat wear a traditional ornament called *ganghi*, which is a round necklace with delicate silver work and three silver chain pendants.

The *Dangis* also wear a *baju-bandh*, which is tied on the arm. It is a silver armlet with filigree workmanship with the delicately woven silver wires resembling the body of a snake. Another circular snake shaped ornament in double silver wires is called *eliya*.

The *Dangi* men are also fond of ornaments. They wear a silver armlet on one hand, called *kadu* or *kankan*. In addition to this, the *Dangi* men wear small ear-rings made of brass or copper. All these silver, brass or copper ornaments of the *Dangis* are fashioned by the local artisans.

The bangles, usually made of silver, brass, copper and lac, are quite interesting for their variety of designs. The silver bangles consist of several pieces of conical motifs which are attached to red cotton strings. The finger-rings made of silver and brass are circular in shape and sometimes decorated with embossed designs.

Wristlets and ear-plugs are equally popular. The wristlets are made of brass and alloy of tin and zinc, while the ear-plugs are made of wood, lac and palm leaves. The *Oraons, Bhariyas* and *Gonds* of Madhya Pradesh and the *Mariyas* of West Bengal have a great fascination for them.

The necklaces made of copper, silver, glass beads, lac and grass are popular. The pendants and neckbands, composed of cylindrical glass beads, are very popular among the *Bhils* of Jhabua and the *Mrias, Murias* and the *Gonds* of the Bastar region of Madhya Pradesh. Sometimes the necklaces are very huge and work like a blouse to cover the breasts of the women.

Among the head ornaments, the bison horn head-dresses are very popular. Head-dresses are also made of bamboo strips and paper. Both are used by many tribes, such as the *Agarias* of

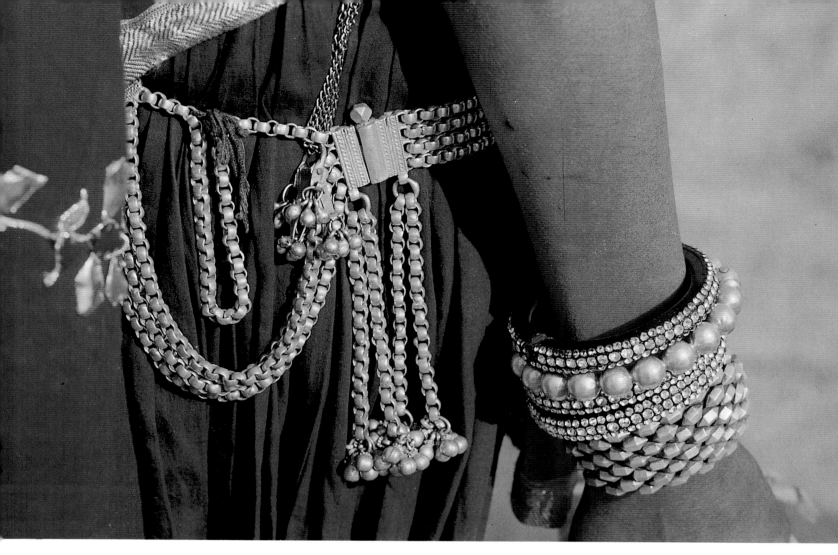

Waistband and bangles. *The bangles are made of silver and glass while the waistband is fashiond from silver chains. Twentieth century AD. Rajasthan.*

Right: **Chest ornament.** *Brass pendant of three trophy heads with the pursed lips stitched together to prevent the spirits of the dead from escaping through the mouths. Twentieth century AD. Nagaland.*
National Museum, New Delhi, 84.957/2.

Brass wristlet.
Twentieth century AD. Nagaland.
National Museum, New Delhi, 89.918.

Ratna-Pariksha

The history of Indian jewellery cannot be considered complete without a study of the gems themselves. India has been one of the greatest trading centres for gems and other precious stones throughout the ancient and medieval periods of Indian history. The vast mass of Indian literature both, indigenous and foreign, have references to Indian gemstones. Subsequently, all this knowledge was compiled into a science called Ratna-Pariksha. The *Arthasastra* of Kautilya, the *Kamasutra* of Vatsyayana, the *Brihatsamhita* of Varahamihira and the *Ratna-Pariksha* of Buddhabhatta are the authoritative texts from the past.

The earliest text in this connection is, no doubt, the *Arthasastra* of Kautilya and then, the *Kamasutra* of Vatsyayana who included gemology among the sixty-four *Anga-Vidyas* or subsidiary arts. The Ratna-Pariksha section in the *Brihatsamhita* of Varahamihira, an astronomer, and the *Ratna-Pariksha* of Buddhabhatta, a Buddhist scholar, are later works datable to the sixth century AD and both have referred to earlier authorities.

The *Brihatsamhita* of Varahamihira has listed twenty-two varieties of stones in the category of *ratnas* (gems) without differentiating between the major gems (*maharatna*) and minor gems (*uparatnas*), a classification which seems to have developed later.

The twenty-two *ratnas* are (1) Vajra (diamond), (2) Indranila (sapphire), (3) Marakata (emerald), (4) Karketana (chrysoberyl), (5) Padmaraga (ruby), (6) Rudhirakhya (carnelian), (7) Vaidurya (cat's eye), (8) Pulaka (garnet), (9) Vimalaka, (10) Raja-mani, (11) Sphatika (rock crystal), (12) Sasikanta (moonstone), (13) Saugandhika (a variety of ruby), (14) Gomedaka (hyacinth), (15) Sankha (shell or mother-of-pearl), (16) Mahanila (a variety of sapphire), (17) Pushparaga (topaz), (18) Brahmamani, (19) Jyotirasa, (20) Sasyaka, (21) Mukta (pearl) and (22) Pravals (coral). Of these, the *Ratna-Pariksha* section of the *Brihatsamhita* deals with four gems in great detail: diamond, pearl, ruby and emerald. The rest like sapphire, chrysoberyl, garnet and so on are mentioned only in passing.

Diamonds : The diamond has been regarded as the most important of all jewels in the treatises. *Brihatsamhita* has mentioned even the areas where diamonds were found in ancient India, like Kosala (in modern Madhya Pradesh), Swarashtra (modern Gujarat), Suparak (in modern Maharashtra), Kalinga (modern Orissa), Venatata (location disputed) and others. In some of these mines, however, no diamonds are found today; in fact it is likely that diamond mining was abandoned there long ago.

The qualities and colours of diamonds from these centres have also been described in *Brihatsamhita*. For example, a diamond from Venatata was stated to be flawless. The Kosala diamonds were said to be of the colour of the Sirisha flower (slightly yellow). Other colours of diamonds mentioned are red, grey and blue.

The different forms and shades of diamonds are attributed to various deities. For example, the six-sided white diamond, shaped like a plantain staff, is attributed to Lord Vishnu; one shaped like the tiger's eye and bluish-red in colour to Agni (Fire God), and that like the Ashoka flower in form and hue (red) to Vayu (Wind God). Amongst the people of the four *varnas* (castes), the red and yellow coloured are attributed to *Kshatriyas* (warrior caste), white diamonds to *Brahmins* (priest caste), Sirisha to *Vaisyas* (merchant caste) and the Black diamonds to the *Sudras* (low caste).

The *tandula* or a rice-grain, which was regarded as equal to eight mustard seeds, was the unit of weight and the maximum weight of a diamond was twenty *tandulas*. Each of the succeeding units was less by two *tandulas* than the preceding one. Buddhabhata in his work has given a price list per unit, where the prices are specified in terms of *Rupaka*, a silver coin. Although most sources agree on the highest price, the other figures differ widely; probably due to local market fluctuations.

The maximum weight of a diamond mentioned (twenty *tandulas*), should be roughly equivalent to four carats, which appears to be quite low. Much heavier diamonds are found even today, in spite of the declining state of the diamond industry.

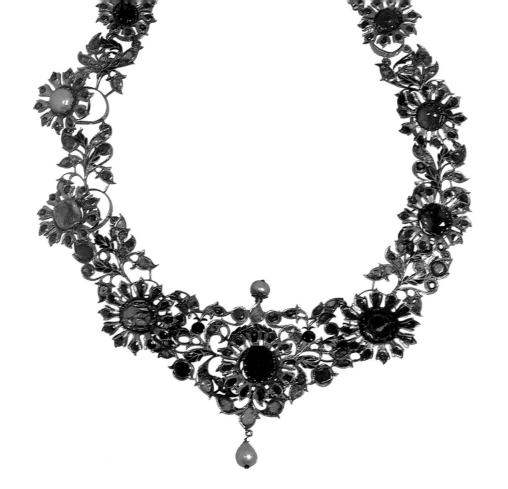

Necklace. *A 'navratan' (nine gems) necklace with a double gold chain at the back; with cutwork and enamelling.*
Early twentieth century AD.
West Bengal.
National Museum, New Delhi, 89.982.

Hence, the twenty *tandulas* probably constituted the unit *dharna*, used specially for weighing diamonds.

Various treatises specified defects which had also to be considered before fixing the price of each diamond. Varahamihira has recommended that the price of a diamond with any of the following defects should go down by about one-eighth of the standard value.

A diamond showing scratches; mixed with clay or gravel; broken; double-faceted; burnt; of odd colour; devoid of lustre; perforated; with bubbles or spots; truncated on points and unduly elongated was treated as defective and fetched a lower price.

A diamond which could not be pierced by any other material, was light in weight and could float on water was considered to be ideal. Even the poet Kalidasa, in his play *Raghuvamsa*, writes that the piercing of all other gems was done by a *vajra* of diamond—*vajra* was a special kind of needle meant for piercing gems.

There existed various beliefs among the people about the magical and medicinal qualities of diamonds. A perfect diamond apparently eliminates fear and the effects of thunderbolts, enemies and poison. It also augments wealth. However, wearing a defective diamond might lead to harm like loss of wealth and even death. Myth also

holds that it might lead to abortion in case of a pregnant lady.

Pearls : According to a charming legend pearls can be obtained from an elephant, serpent, oyster, conch, clouds, bamboo, fish and hog. Pearls obtained from oysters have traditionally been regarded as the best and have always been in great demand. Simhala (modern Sri Lanka) has been famous for its pearl industry right from ancient times. Even ancient historians and geographers like Megasthenes, Fa-hien and Periplus speak about the large-sized Sinhalese (Sri Lankan) pearls. Fa-hien informs us that the king of the country had full control over the pearl producing islands and took three out of ten pearls for the royal treasuries. The most priceless pearls went to the treasury of the Buddhist priests.

The quality of pearls found in different places varied. The pearls found in Paraloka (now in Kerala), were white or yellow, mixed with gravel and uneven. Pearls from Swarashtra were just the right size and of the shade of butter. The pearls found from the river Tamraparni (Tamil Nadu) had either a coppery hue or were white and lustrous. Pearls from Parasava (Persian Gulf) are brilliant, white and very heavy. The Himalayan pearls were light, broken, large, dual coated and the colour of yoghurt. The Kaubera (not

identified) pearls were uneven, black or white, light, brilliant and of large size.

As in the case of diamonds, various pearls were also associated with deities. For example, some pearls were attributed to Indra (king of the gods), those of the shade of orpiment to Varuna (God of water), those of black colour to Yama (god of death), those coloured like the ripe pomegranate fruit or *gunja* to Vayu and pearls resembling smokeless fire or lotus to Agni.

The weight and intrinsic quality of pearls determined its price. The value of inferior quality pearls was reduced and the price of slightly black, white, yellowish, copper-tinged and uneven pearls was fixed at one-third less than that of a good pearl.

Rubies : Varhamihira in his *Brihatsamhita* informs us about three kinds of rubies: *saugandhika* (originating from sulphur), *kuruvinda* (originating from cinnabar) and *sphatika* (originating from crystal). The ruby originating from sulphur was of the colour of the lotus or the juice of the rose apple fruit; that which originated in cinnabar was grey (*sabala*), of dim brilliance and mixed with mineral substances; and those coming from rock crystal were very lustrous, of numerous shades and pure. Kautilya regards *saugandhika* as the best.

The price of ruby was determined keeping in mind its weight, colour, lustre and shape. Rubies of intermediate weight were priced according to their quality. Defective rubies fetched half of the market price, if the colour was not dark enough. A ruby lacking in lustre, fetched only one-eighth of the price of a good ruby; a ruby with numerous defects got one-twelfth, while one with smoky colour and many holes fetched only one-two hundredth.

Emeralds : Emeralds have received only a sketchy attention from ancient scholars. Varahamihira has made just a casual reference to emeralds. He has described the various colours of emeralds, such as emeralds of the hue of a parrot's wing, bamboo leaves (green), plantain tree (greyish yellow) and a sirisha flower (slightly yellowish). An emerald of good quality has also been prescribed for various religious rites to please the divinity.

Actually the important emerald mines in India were probably not known till 1940, when dark green emeralds at Kaliguman near Udaipur in Rajasthan were found.

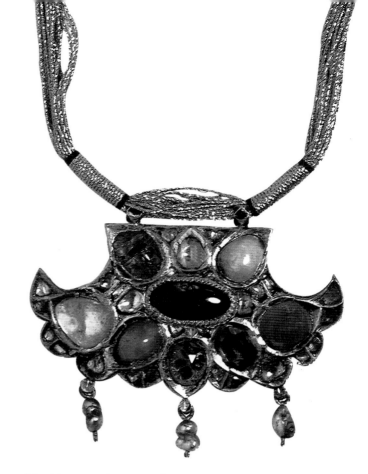

Necklace. *A 'navratan' (nine gems) necklace enamelled on the reverse.*
Mughal period, eighteenth century AD.
Provenance unknown.
National Museum, New Delhi, 56.83/1.

Emeralds have, however, been popular in India since the late sixteenth century when they were first imported into India by Spanish traders through Bengal from the New World (America) via Manilla in the Philippines. The great jewels of the Mughals were created out of emeralds and Nadir Shah of Iran, when he invaded India, took away thousands of precious emeralds as booty, which still form part of the Crown Jewels of Iran. Jaipur was the famous centre to fashion emeralds. The most precious Colombian emerald which has survived from the Mughal period is known as the Taj Mahal Emerald which weighs 141.13 carats and has stylised leaves and flowers carved on it.

It is, thus, evident that gems played a major role in the fashioning of jewels in India right from ancient times. The ornaments, as mentioned by Varahamihira, were sometimes carved out of real gems and often were studded with gems. Besides the precious stones, semi-precious stones like rock crystal, jade, jasper, agate, and other materials, like coral and mother of pearl, were also employed to design costly and beautiful ornaments to be worn both by men and women.

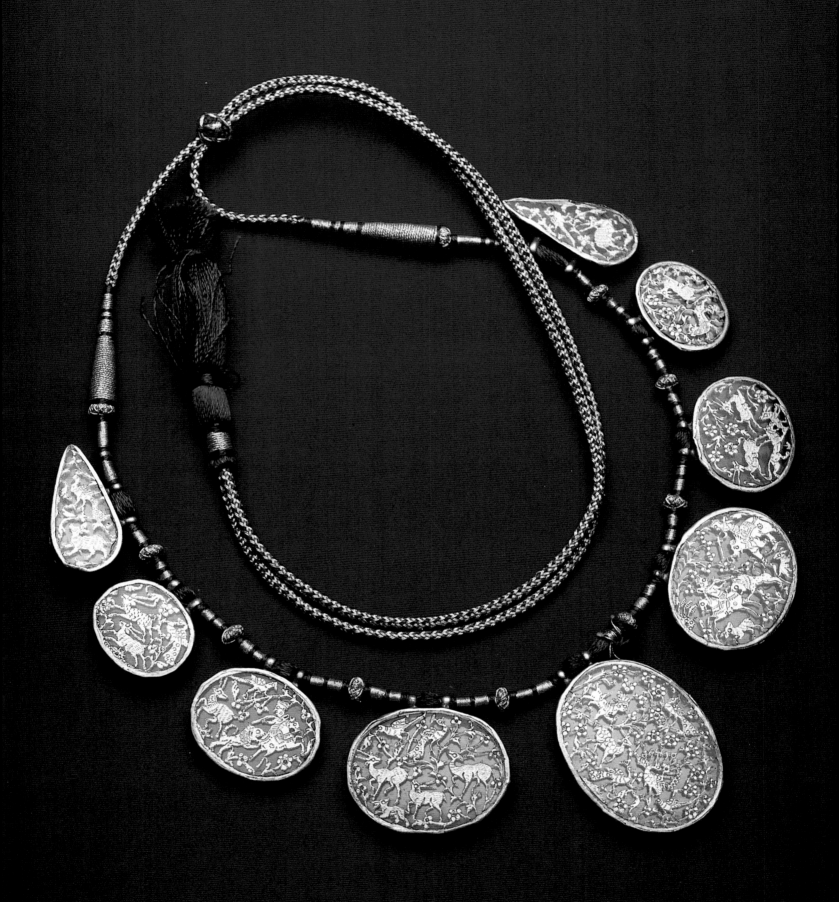

The Craft of Jewellery Making

A large number of archaeological excavations conducted throughout the country and their variety of finds would suggest an impressive development of metal technology in ancient India even prior to the Indus Valley civilisation. In northern India, copper and bronze were used as substitutes to stone sometime between 4000 and 3300 BC. The objects recovered from the Indus Valley leave no room for doubt that metallurgy was fully developed and numerous techniques were employed then to produce a great variety of ornaments, pots, pans, tools and weapons. The Harappan tubular drills are the earliest known in the world and show a high degree of skill in metal forging.

In Kautilya's *Arthashastra*, written in the fourth century BC, we get written accounts of the highly developed science of metallurgy. From the Mauryan period onwards, there is plenty of archaeological evidence of the use of even precious

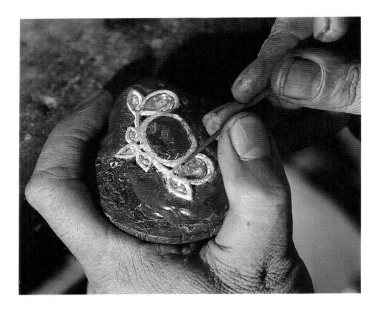

A jeweller doing fine 'kundan' (inlay) work.

Facing page: **Gold enamelled necklace.** *With nine pendants and gold engraving on green background. Eighteenth century AD. Pratapgarh, Rajasthan.* Bharat Kala Bhavan, Varanasi, 5/9990.

A jeweller working on a bangle.

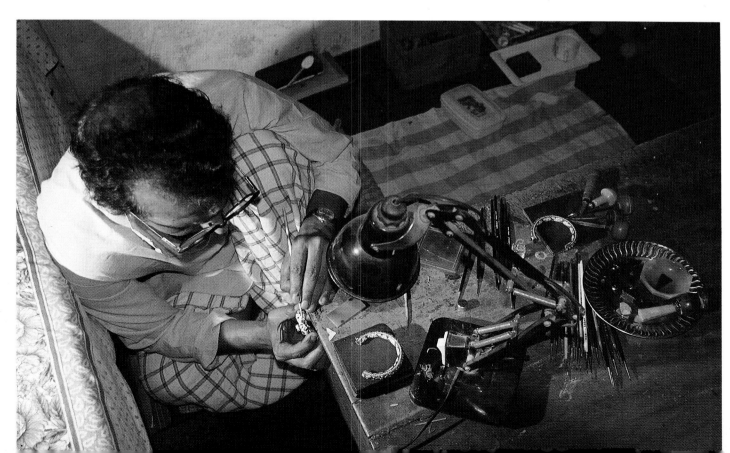

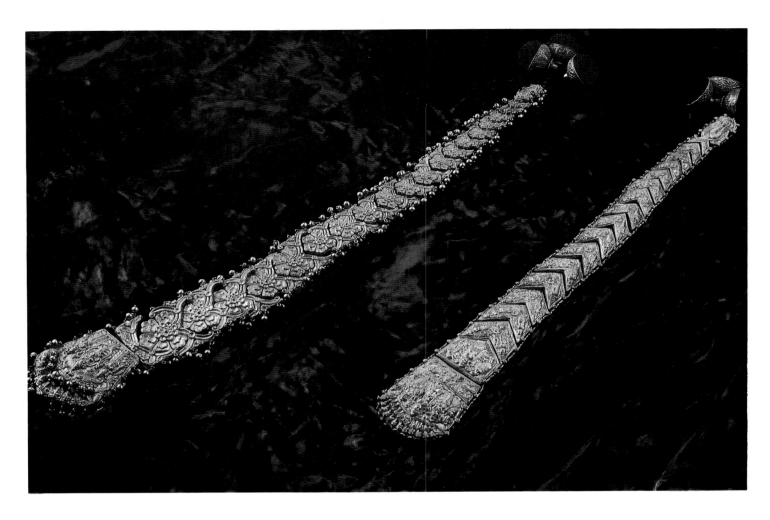

Left: **Gold braid.** *Made up of several pendants in the form of plaits. The top rectangular pendant shows Rama's coronation. Rama is flanked by Sita and Bharata on one side and Lakshmana and Shatrughna on the other. They are represented under the canopy of the serpent, Adisesha, suggestive of supreme royalty.* Right: **Gold braid.** *The plait ornament is made of seperate pieces. The top pendant shows Vishnu flanked by Sridevi and Bhudevi. The last pendant is in the form of a fish indicating the first incarnation of Vishnu.*
Sixteenth century AD. Ghatt village, Gadwal taluk, A.P.
State Museum, Hyderabad, T.T. No. 17/1980.

metals, like gold, silver, copper, bronze and so on, to produce ornaments, vessels and other luxury items for the nobility. During the post-Mauryan age, foreign influences become evident due to the advent of the Sakas, Parthians and Kushans.

Tools

For preparing ornaments of gold, silver and copper, many inlays of moulds, dies of copper, bronze, stone, ivory and so on were used. In Taxila, a large variety of stones for inlay and incrustation, consisting of thin discs of porcelain, agate, rock crystals and jade were recovered. Similarly, a variety of moulds made of stone and terracotta for casting metal ornaments were also found. Softer stones, such as slate, claystone, steatite, mica, schist and milestone were used for preparing the moulds. A huge range of copper dies for preparing personal ornaments like pendants, bead necklaces, ear-pendants, belts, girdles and so on were used in Taxila. On these dies metal sheets of gold, silver, copper and bronze were hammered in, with the help of punches, and converted into articles of jewellery.

The excavations at a few ancient sites have also brought to light several metalsmith's workshops which consist of actual smelting workshops, blacksmith's forges, furnaces, tools for the manufacture of finished and semi-finished articles. These workshops provide ample evidence that the metal technology as well as the working of the metalsmiths in India had made considerable advances even during the early historic period.

At Ujjain, a blacksmith's forge (500-200 BC) includes accessories, such as anvils, crucibles and

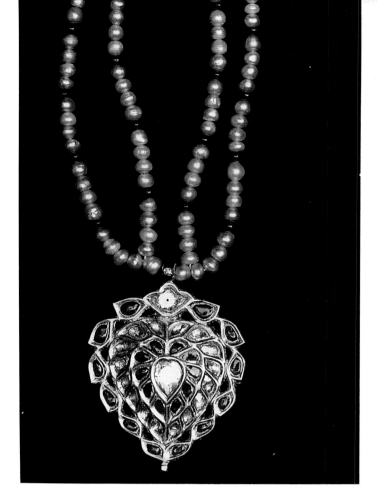

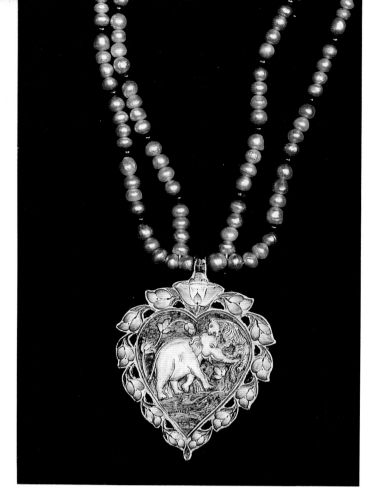

Gold pendant. *A leaf-shaped pendant studded with stones. The reverse, enamelled in distinctive Benaras style with a hunting scene, is shown on the right. Nineteenth century AD. Varanasi.*

slags, the grooves for the introduction of the working end of blower, a water-jar stand, a large bowl and iron tools, like the pincers, a chisel near the forge and ash and charcoal. Another small smelting workshop with furnaces exposed at Rairh, datable to the Kushan period, has a small room with two furnaces inside.

Archaeological excavations of Nagarjunakonda have also yielded a goldsmith's shop in a house situated on the main street of the ancient township. The terracotta crucibles, a touch-stone, an iron pestle, terracotta and stone weights, terracotta bangles, and ear-rings alongwith oblong moulds were recovered from the shop which can be dated to the third or fourth centuries AD. We may therefore infer that the metal technology as well as the working of the metalsmiths in India had already made considerable advances during the early historic period.

The Indian goldsmith, known as *Sunar*, worked entirely with a small set of indigenous tools and implements. All his work was basically manual where he depended entirely on his personal experience, dexterity and judgement. The profession was hereditary and carried on from father to son without much external influence. The basic elements of the craft, the traditional forms, motifs and designs of ornaments and the materials for his work were based on oral

An enamel worker in Jaipur crafting a bracelet.

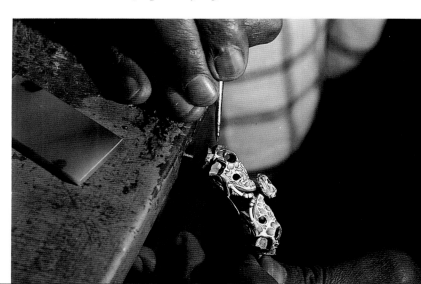

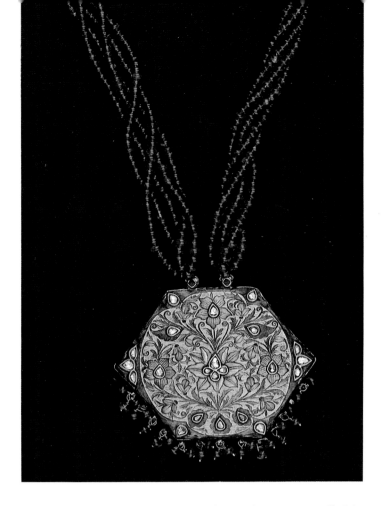

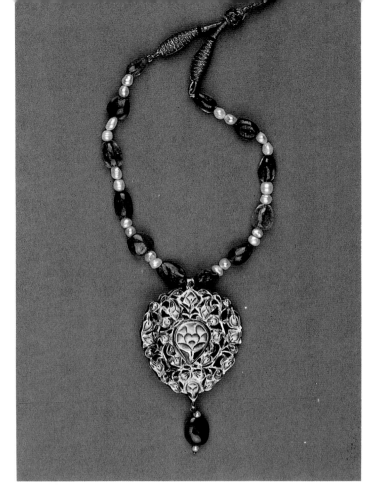

Necklace with gold pendant. *The pendant is enamelled in pink and green depicting a floral design. Nineteenth century AD. Varanasi.*

Necklace. *A gold necklace strung with precious beads, with the pendant enamelled in pink. Nineteenth century AD. Varanasi.*

instructions and experience. Every village had a family of goldsmiths who would fulfil the needs of the rural community. Of course, the city-based goldsmiths were comparatively more exposed to outside influences in so far as they could copy the forms, motifs and designs of ornaments provided to them as models for fashioning new types of ornaments, which suited the tastes of their new customers.

The city-based craft of jewellery in India was a product of teamwork, wherein a band of skilled workers were involved to complete the work right from purifying the metal to the encrustation of finished gems. The work of refining the various metals was done by a particular class of goldsmith, known as *nyariya*. He did the work of melting old ornaments or purifying gold and silver from alloy. The work of a goldsmith was to prepare the skeleton ornament and send it to the *chitera* for engraving. After completing the patterns on gold, the piece was sent to the *garia* who would work out the patterns and designs. This work was called

Gadhat. The *murassakar* or *kundanasaz* was engaged in the studding of the gems. Again, a different set of workers, called *minasaz*, were engaged in enamelling. This type of specialisation in the city brought about a much better finish than that achieved in villages where a single individual, the *Sunar*, used to undertake the entire process single-handed.

The tools and implements of goldsmiths are few and simple. The apparatus for heating and melting the metals include a furnace (*angetha*), crucibles (*gharya*), blowpipe (*nal* or *phunkani*) and small curved blowpipes (*bangual*). For hammering, there is an anvil (*nihai*) and the hammer (*hathaura*). He has various long and small tongs (*chimta* or *chimti*), pincers (*samsi* or *zamburi*), scissors (*katris*), file (*reti*) and chisels (*chheni*) to do his job. For drawing wires, the *Sunar* uses the wire-drawer (*jantra*), which is an iron plate perforated with circular holes of different sizes through which the metal bar is drawn out until it is gradually reduced to the

desired thickness. A cube (*kansula*) of brass or bell metal (*kansa*) with circular hollows at the side is used to hammer out the small plates of metal into separate halves of round ornaments, such as the *ghungroos* (small bells) which are joined to chains, bracelets and anklets. Again, there are the dies (*thappa*) of various shapes and sizes required for ornaments. The dies are used to bring out the patterns by hammering and heating. They are named after ornaments such as the *thappa churi* (a bracelets mould), the *thappa tabiz* (amulet mould) and so on.

In addition to the above equipment and tools, the Indian goldsmiths use certain other instruments to do the filigree work. The heavy pincers (*silari*) and light pincers (*patangir* or *pilas*) are used for pulling wire. The *qalam* (pointed iron pen) is required for chasing the patterns. A set of *salais* are used for chiselling and engraving. The *balancha* is a hand brush for cleaning. The *meghnala* or mica plates are required for arranging and soldering the wires of filigree work. The *tara gola nali* is a wooden cylinder around which the gold and silver wires

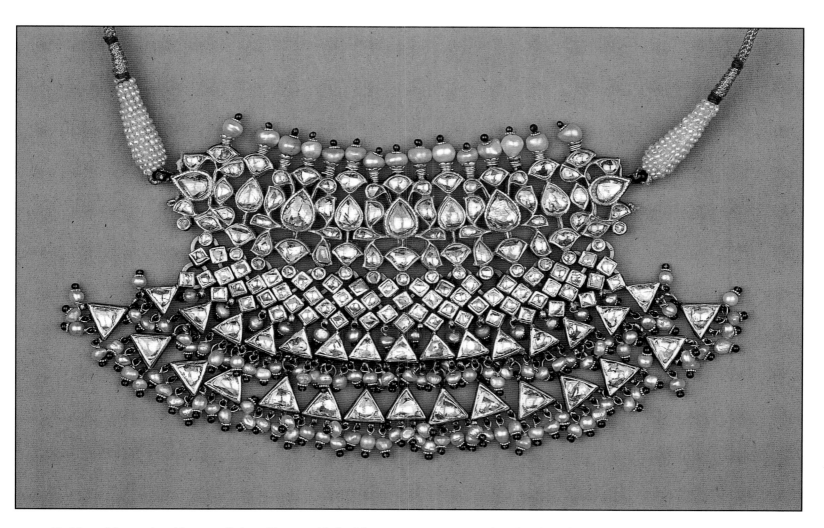

Gold necklace. *A gold enamelled necklace studded with precious and semi-precious stones. The enamelled reverse is shown on the following page.*
Nineteenth century AD. Bikaner.

are wound. The *hatol* is another instrument in the shape of an iron needle over which gold and silver wires are worked for making chains. The set of tools required for enamel work were the kiln, pestle and mortar, tongs, forceps and *patra* (brass palette).

The few indigenous chemicals used by the *Sunar* in the process of his work are the *suhaga* (borax) as a flux in melting metals and mango parings (*amachul*) to clean and brighten the objects. The application of salt is completed with the help of sal ammoniac (*nausadar*) and alum

(*phitkari*). Finally, the *manik ret* (ruby dust) is rubbed over the ornament to level the surface of the finished articles. *Shan* or *korand* was a stick of corundum powder used for bringing lustre to the ornaments.

Techniques

The process of fashioning jewellery in India involved various techniques. The metal required for the fashioning of an ornament had to be first examined for its purity through a special

soldering gold ornaments and zinc in silver ones. The technique is locally known as *tanka*.

The *Ain-i-Akbari* mentions certain classes of skilled craftsmen who were responsible for fashioning the jewellery of the Mughal period. The *zerneshan* inlaid with gold, silver, crystal, carnelian or steel. The *koftgar* inlaid gold and silver to decorate arms. The *minakar* enamelled cups, flagons, rings and so on. The *sadehkar* did the plain work in gold or silver. The *subhehkar* did the pierced workmanship or filigree. The *minubbetkar* decorated the surface of the metal

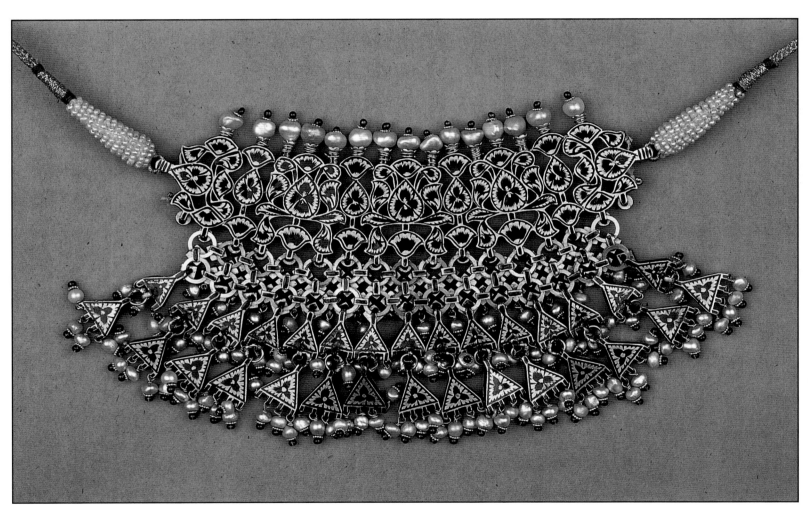

technique called assaying. The common method for assaying was to rub the metal on the touchstone (*kasauti*), which left a mark of a certain colour suggesting the purity of metal or the amount of alloy of other metals contained in it. Similarly, alloying was sometimes found necessary to give a certain hardness to the metal for working intricate patterns and designs on it. Gold was alloyed with copper or silver and silver was alloyed with copper or zinc. Different parts of the ornament were joined together by soldering. The gold, silver and copper were mixed in

with flowers by stamping. The *heremkar* inlaid the jewels with little grains of gold. The *seembast* made gold or silver lace used for sword belts and so on. The *sewadhkar* filled ornaments with *sewad* or black varnish, engraved upon gold or silver and polished the ground. The black varnish was composed of silver, lead, copper and brimstone. The *zirkowb* made the gold and silver plates. Besides, there were engravers, lapidaries, founders and other artisans.

The different types of works in fashioning Indian jewellery can be divided into four major

categories. Firstly, the *Sunar* hammers down the metal into the desired shape or form of an ornament; or he may cast it in a die. Secondly, the patterns are brought out by chasing or embossing. Thirdly, the enamelling on the back of the ornaments and fourthly, the studding of gems.

Casting : At first, a resin model of the ornament is prepared using the fingers only, afterwards it is enclosed in a mixture of clay and cowdung. The enclosed model is provided with a vent, which is sealed with clay to the mouth of the crucible containing the metal and later placed on the fire. After gradual heating, the molten metal enters through the vent and reaches the resin model. The resin model melts ultimately and gives shape to the molten metal. Thus, an exact replica of the resin model is produced in gold or silver. This is probably the crude form of the present 'cire-perdue' or lost-wax method.

Thappa Technique : Commonly, ornaments are prepared by melting the metal and then hammering it into the desired shape. This method

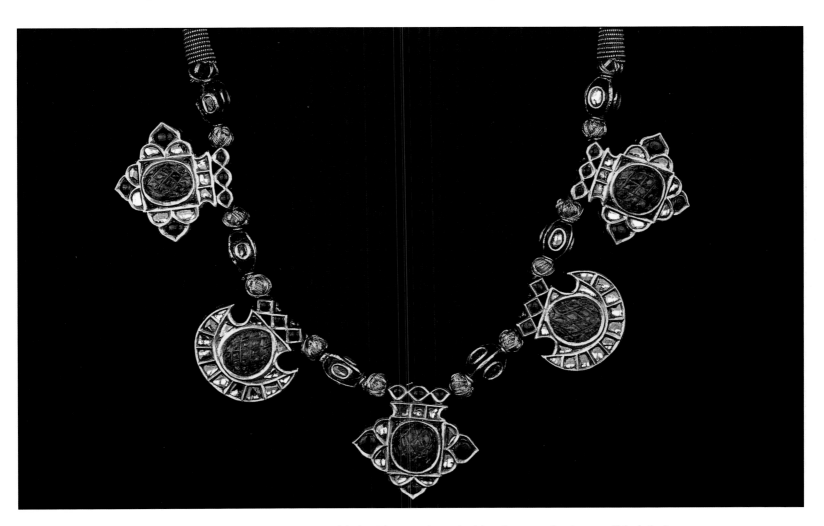

Gold necklace. *A necklace with five pendants studded with emeralds and rubies. The following page shows the reverse, enamelled with floral designs.*
Eighteenth century AD. Bikaner.

is suitable for producing solid (*thos*) ornaments. However if the ornament is to be hollow (*pola*), the two halves are first produced and then joined together with solder. The patterned ornaments, like the ear-rings with floral designs, bracelets and amulets are produced by putting small circular pieces of molten metal on the dies (*thappa*) and hammering them until the metal takes the shape required for an ornament. All the smaller units prepared in this process are put on plain pieces of metal and joined together with solder. The ornament is again put in the fire for a few

minutes and then taken out for cleaning and brightening the surface. Later, it is passed on to the *nakash* for engraving artistic designs, which are enamelled.

Gilding : The *mulammas* or beaten gold leaf is applied by skilled craftsmen called *mulammasaz*. It is the technique of gold-gilding. After heating, the gold leaf is set with the help of a piece of agate called *muhari* or *muhara*. The ornament is then sent to the *zilasaz* who gives the finishing touches to the surface.

Inlay Work : The origin of inlay work in India goes back to remote antiquity. There has been a misconception among scholars that the inlay technique in India came from Damascus and hence, the name damascening. In fact, the origin of inlay work in Damascus appears to be quite late, not earlier than the thirteenth century, as compared to its older Indian origin. The technology of a limited use of silver and copper inlay on bronze or brass in the Near East may indeed have migrated from the Abbasid heartlands during eleventh to twelfth centuries

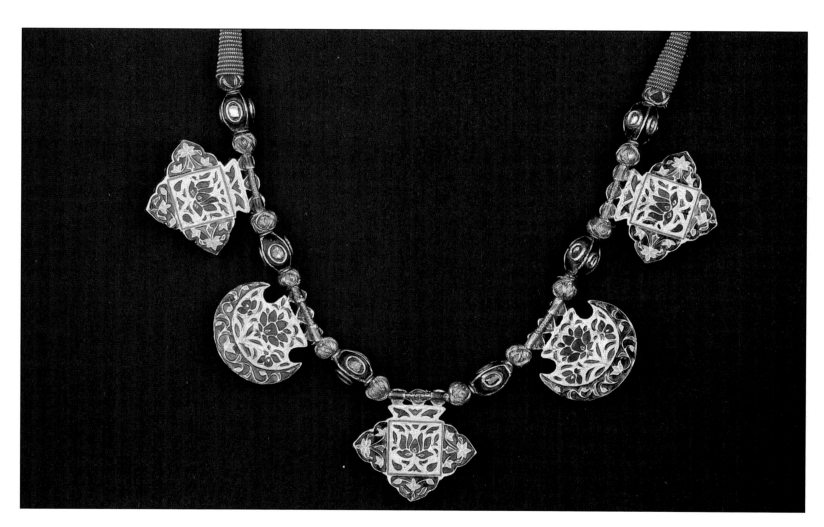

Filigree : Filigree is one of the earliest techniques employed in India for fashioning ornaments. The work is done in pure silver, with the metal cast into long bars which are cut into small pieces and then are beaten and drawn into wires, with the help of a *jantra*. The wires are taken one by one and carefully arranged and cemented on a sheet of mica to produce parts of intricate designs and patterns. Later, the different parts are united by soldering. Lastly, the process of cleaning and brightening the surface is completed to give the ornament a snowy appearance.

AD which, in its own turn, was influenced by Kashmiri work, a geographically much closer and adjoining region. The flowering of the bronze casting technique in Kashmir is associated with the Karkotas, who assumed power in Kashmir sometime in seventh century AD. The great Karkota king, Lalitaditya ruled over Kashmir in the first half of the eighth century AD and it is to his reign that the fine Buddhist images found here are largely dated. Buddhism appears to have continued in eastern Iran and Afghanistan for a few centuries after the Islamic conquest and many

such images must have been cast there during Islamic times.

The influence of Kashmir on the inlay work of the Near Eastern Islamic world during its early days therefore would be a more logical conclusion. Perhaps this tradition, rather than the Abbasid, was responsible for the introduction of small quantities of inlay into Samanid and Ghaznavid (of central Asia) bronze sculptures. The inlay of turquoise and copper for the eyes of lion-shaped incense burners, presently housed in the Louvre and the Hermitage and signed by 'Al ibn Muhammad al-Taji', are indeed reminiscent of the early Buddhist tradition. The pre-eminent tradition of the Samanid and Ghaznavid lands for the production of cast-bronze objects in a wide variety of shapes would suggest a thriving Buddhist tradition which produced huge quantities of images in these lands prior to the advent of Islam; which might be responsible for the subsequent neighbouring Islamic tradition of inlay workmanship. It is only in the second half of the twelfth and the beginning of the thirteenth centuries that Khurasan and Herat in particular,

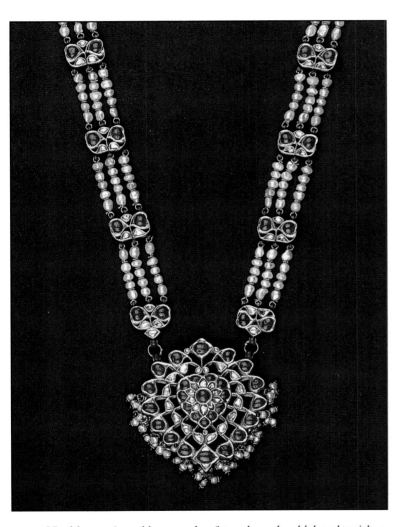
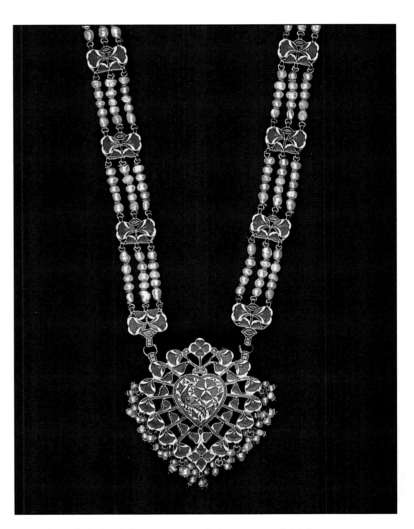

Necklace. *A necklace made of pearls and gold bands with a gold pendant studded with precious stones. The enamelled reverse is shown on the right.*
Twentieth century AD. Bikaner.

produced inlaid bronzes and brasses of hitherto unparalleled splendour and intricacy. Here the quality of the casting and the sheet working is superb which would suggest a long standing tradition in the past. The inlaid objects made of brass and copper found in Iraq and Syria follow the Iranian tradition; the same tradition came into vogue in Damascus during the thirteenth century AD. Hence, it would not be incorrect to suggest that the inlay technique in the Near East and the Arab world had originated in Kashmir, which had an earlier tradition of bronze casting.

Inlay is meant to fill depressions by the use of silver or copper wire on the surface of another metal. In India, inlay has generally been practised on the finished objects of metal, stone and wood. The main purpose of inlaying was to beautify the surface of art objects (ornaments, weapons or wooden furniture), for delineating floral motifs, human and animal figures, abstract motifs and designs in contrasting colours.

There are a number of techniques which have been applied to attain excellence in the inlay workmanship of India.

rubbing and hammering are repeated with greater force. The silver or gold used is very soft and pure.

Koftgari is a summary process. The metal surface to be decorated is first cut across sharp and deep lines where the patterns are to be placed. The word *Koft* literally means sorrow and has been used for this technique only on account of the inferior technology used.

Tehnishan : Here the pattern is cut in fairly deep grooves. The depth of the grooves should be

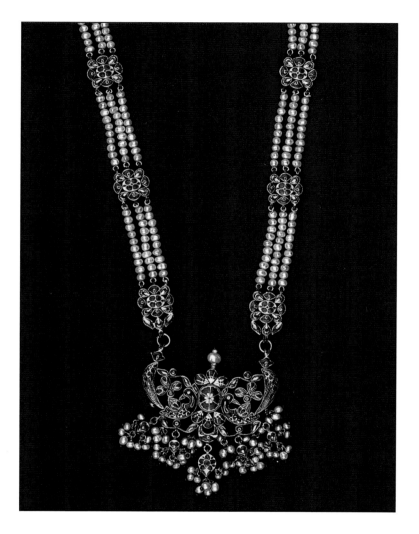

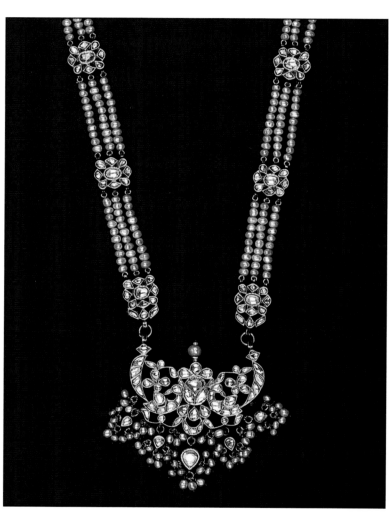

Koftgari or False Damascening : Koftgari is done by first drawing out the pattern on the metal surface with a hard steel needle or *salai*. This leaves a line sufficiently deep to catch the very fine wire laid-on. The wire is of pure silver or gold drawn through a steel *jandri*. The wire is then hammered into the metal according to the pattern and lines already drawn, the whole is then heated and again hammered. Then the surface is polished with white porous stone; where the soft silver or gold is required to be spread, the

Necklace. *A necklace studded with stones and pearls. The enamelled reverse is shown on the left. Twentieth century AD. Delhi.*

about two-thirds of the diameter of the wires. The pure gold or silver metal is pressed into the grooves and then hammered down flat. The inlay should be of the softest metal, usually pure, in the case of gold or silver.

Zarnishan or Zarbuland : It is practically the same process of decoration as *Tehnishan* except that the silver wires beaten in are not polished but are allowed to remain projecting above the surface. It requires a number of hammers of different sizes. The method is to press wire into the grooves and set up the edges on the latter with a blunt punch or chisel. This holds the inlay in position much more firmly. It leaves the inlay in relief instead of being flattened down, as in the case of *Tehnishan* and gives a much more brilliant and permanent effect than *Koftgari*.

Tarkashi : In this technique, a fine wire of silver is drawn and the design is made from one single wire. It is a very time consuming and intricate process demanding great patience and precision.

Aftabi : In the *Aftabi* technique, the silver sheet is cut into the exact size of the designs which are traced on it with pencil from paper. Instead of fixing the silver sheet into the engraved pattern, the designs are cut out on silver sheet and fixed to the object so that the motif emerges out pitch black against the brilliant silver ground. The designs are carved out in relief on the surface of the object and the silver sheet, cut out accordingly, is so employed that the relief design emerges in black.

Munabatkari : In this method of ornamentation, patterns of flowers and so on are wrought on a

slightly raised level over the surface of the article in relief and one can even feel, with the hand, the designs overlaid on the surface. For this purpose, lead is first laid on articles in the shape of the required design. On those raised spaces of lead, silver is fixed in the *Tehnishan* technique.

Enamelling : Enamelling is another technique which has been practised in India since antiquity. The enamel beads from the various Buddhist sites in India trace the history of enamelling to the early historic period. Such enamelled beads are divided into two groups: the white enamel on a black or carnelian ground and the black enamel on grey or white agate background. The enamel patterns are chiefly pentagonal, hexagonal, circles with dots in the centre, or else five rows of tiny spots or two or three bands running round the beads. The circle and dot pattern is so arranged on the round beads as to form the triad symbol.

The enamelling in medieval India was generally applied in grooves. The motif or patterns were drawn by the *chitera* or artist and the piece was handed over to the goldsmith, who completed his work leaving the grooves to be enamelled. The enameller or *minakar* first cleaned and burnished the plate and then applied his colours in order of their hardness or the power to resist fire; beginning with the hardest or that which resists fire the most. All the known colours can be

Bracelet. *Diamonds set in a green ground with gilded chain clasps. The enamelled reverse of the same bracelet is shown on the following page. Mughal period, eighteenth century AD. Rajasthan.*

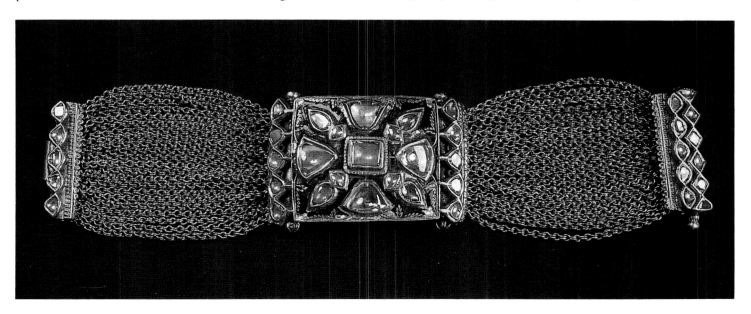

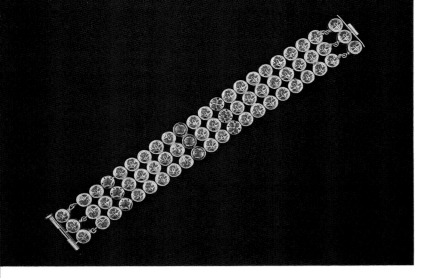

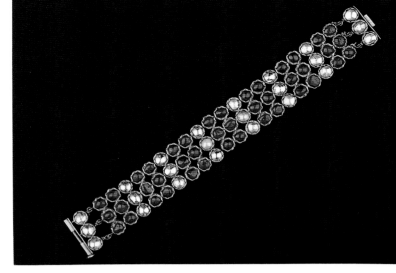

applied to gold. Black, green, blue, dark yellow, orange, pink and a peculiar salmon can be applied to silver. Only the white, black and pink colours can be applied to copper. Some colours in decreasing order of hardness are white, blue, black, yellow, pink, green and red. The pure ruby red, being the most delicate, requires great care and the precision of an experienced craftsman. The Jaipur enamellers are the best in handling this colour. The pink enamel of Banaras is equally famous.

The colours are mineral oxides which are ground in pestle and mortar, and mixed with water. The colours are then filled in the grooves very cautiously with a brush, much in the same way as a picture is painted. The paint, if it overflows, is carefully wiped with pieces of cotton. The articles are then left in the fire for half an hour or so, when the enamel firmly sets in. It is then rubbed with *kurand* or corundum-bone and then the article is repolished by gentle heating. The last process is to rub it with the file and clean it with the acid of tamarind or lemon.

Bracelet. *A gold enamelled bracelet with rubies and diamonds. The enamelled reverse is shown on the left. Twentieth century AD. Jaipur.*

Another famous centre for a different kind of enamelling was at Pratapgarh. Sir George Watt has described this technique; as he says, 'the article is made of a piece of green or red coloured glass, or thick layer of enamel, the crude material for which is imported from Kashmir'; he further writes, 'a frame of silver wire, of the exact size and shape of the glass, is next made, and across this is attached a sheet of fairly thick gold leaf. This is then embedded on lac and the pattern punched out and chased on the gold. The glass is then semi-fused, and while still hot the rim of silver and film of gold are slipped over the edge and pressed on to the surface of the glass. The article is again heated until a sort of fusion takes place and the gold and glass become securely united. Before mounting the article, a piece of silver tin-foil is placed underneath the glass to give it brilliancy.'

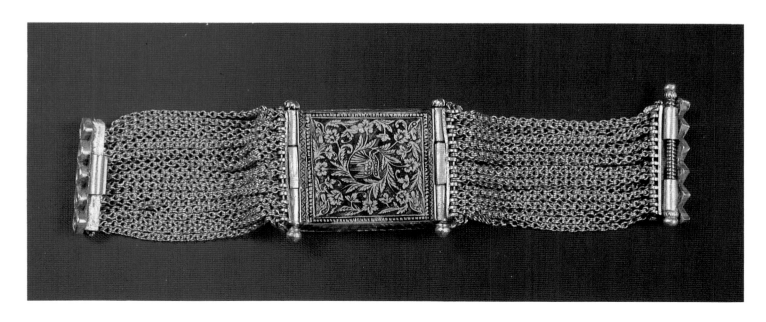

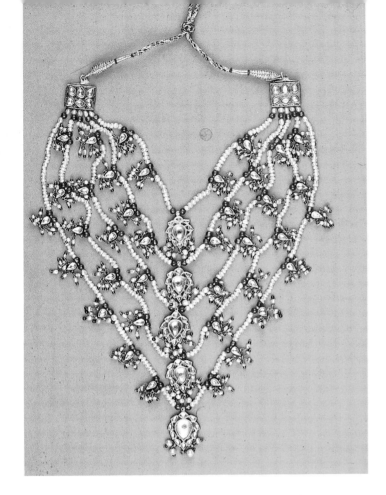

Necklace. *A gold 'panchlara' (five-strand necklace) enamelled and set with pearls and stones. Twentieth century AD. Rajasthan.*

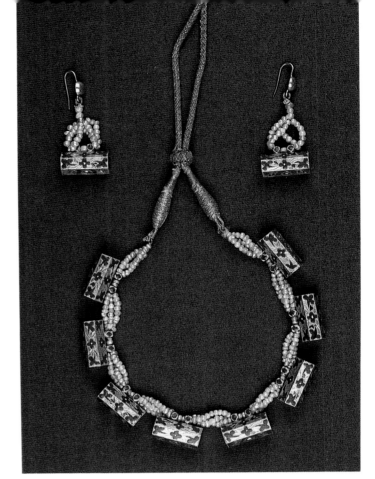

Necklace and ear-rings. *A gold enamelled necklace and ear-rings. Twentieth century AD. Delhi.*

The Studding of Gems (Manikya-bandhan)

India has a hoary tradition of faceting and studding of precious and semi-precious stones. The discovery of crystal reliquaries from various early Buddhist stupas in different parts of the country, such as Bhattiprohi in Andhra Pradesh, belonging to the third century BC, are adequate proof that the technique of carving hard stones was known in India prior to the Christian era. The process of fashioning exquisite art forms out of precious and semi-precious stones was a slow and patient one with the help of abrasives which were powdered out of harder stones such as agate, rubies and diamonds. Thus, the term carving is erroneous as the precious stones could not be cut even with the best of metals. The abrasives used and prepared right from ancient times came from quartz, sand, crushed almandine, garnets, corundum and diamonds.

The abrasives were prepared by pounding, grinding and sifting of raw stones and later on turned into paste ready to be applied. Tools were generally made of wood, lac and metal. Amongst the tools commonly used by the craftsmen in ancient and medieval India are the lap wheels and diamond drills of various sizes. The notable difference between the Chinese and Indian artisans was that in China they preferred the treadle lathe in place of the bow lathe which is still used in India by the traditional craftsmen who have not succumbed to the modern electric motor.

The earliest pieces of Indian jewellery are long tubular beads made of carnelian and jadeite, belonging to Indus Valley civilisation. A chance discovery of a bead-maker's workshop would allow us to draw an accurate picture of gem cutting tools and techniques of this period. According to Stuart Piggot, a noted scholar, 'At Chanhu-daro a bead maker's shop was excavated and the technique of making the long carnelian or agate beads could be recovered. The rough stone was first split and sawn into a bar, about three inches in length and square in section: a copper saw

using abrasive such as emery or powdered quartz was probably used. This bar was then carefully flaked to a round cylinder and then ground and polished, and at the same time the central longitudinal perforation was bored by means of tiny stone drills. These were rods about one and half inches long and 0.12 inch in diameter, with a cup shaped hollow at one end to hold the abrasive powder with which the actual boring was performed....'

It was at the beginning of the Christian era that south India became the centre of gem mining and trade. Tamil literature speaks of the flourishing gem-trade in the first few centuries of the Christian era at Kaveripattinam and Madurai. Kautilya considered the southern trade more profitable because diamonds, rubies, pearls and gold were plentiful in the southern trade-route. A number of Sanskrit poets and authors, such as Kalidasa, Bhartrahari and Subandhu etc speak of various tools, such as the diamond-pointed drill for boring holes, sana and sana-chakra or the grinding wheel for cutting and polishing gems which were used by the Indian lapidaries during the early historic period.

Regarding the tools and equipment of the Indian lapidary during the early medieval period of Indian history, a recently published manual on gemmology entitled *Agastyasamhita*, which was copied from an earlier text in 1334-35 AD, throws very valuable light on the new tools and techniques which had come into vogue. It speaks about the manual and mechanical processes adopted for fashioning the gems at that time. There are nine varieties of grinding and polishing wheels (*sana*) and six types of diamond drills (*vajra*) described in the manuscript.

Grinding Wheels : The first five varieties were cast with varying proportions of schellac (*laksha*) and corundum (*kuruvinda*). Crushed corundum was thoroughly mixed with molten shellac, the mixture was cooled and moulded into the shape of discs. A gemstone was ground successively on all these grinding wheels to give it a pre-final finish.

Polishing Wheels : There were four types of polishing wheels; each for a different species of gems. The wheels are *kasthasana* (made of smooth timber), *mrcchasana* (cast with equal parts of shellac and black earth), *tamrasana* (copper wheel), *diptcsana* (made of timber and coated with the ash of burnt cow dung).

Different types of polishing powders, mixed with water and made into paste (*vatika*) were applied to these wheels. It is stated that hard gems (*maharatna*) such as ruby, sapphire and emerald were polished on the copper wheel with the powder of burnt *gara*. The *gara* denotes the dust of the gemstone falling from the grinding wheel which is collected and used as polishing powder. The other wheels were possibly used for polishing gems of lesser hardness.

Diamond Drills : The diamond drills were called *vajras*. To the end of the *vajrachakra* some straight pieces of diamond were affixed so as to form a wheel. It was used for joining gems. *Vedhavajra* had a solid piece of diamond cemented to the tip of the metal rod of the drill and this tool was used for boring holes in gem beads. The third, *suchivajra* consisted of a large diamond with a needle-sharp tip meant for carving various types of figurines. Again, *lekhavajra* was employed for engraving. *Chhedanavajra* had a diamond with a cutting edge attached to the drill. It might have been used for grinding the diamond to the desired shape. Lastly, *upamarajanavajra* appears to have a diamond with smooth surface affixed to the drill and it was used for polishing diamonds. These drills must have been rotated by means of a bow.

A Mughal miniature showing the horizontal drill was first recognised by the noted historian, Irfan Habib. Here, the drill rod passes through three upright wooden planks. The lapidary is rotating it with a bow held in his left hand, and with the right hand pressing a ruby against the end-piece of the drill. A pitcher, perhaps containing water for lubrication, is also seen. This particular visual in the form of a Mughal miniature throws light on the use of these tools in a most authentic manner.

The information provided by *Agastyasamhita* is further confirmed by the accounts of the European travellers who visited India during the seventeenth century AD. John Fryer, who saw similar grinding wheels cast with a mixture of shellac and corundum for cutting and polishing gems at Surat in 1675 AD, thus reports, 'I went the same day to a Moorman that cuts all sorts of stones, except Diamonds, with a certain wheel made of lacre and stone ground and incorporated only to be had at Cochin and there the Name is Known.'

The statement that such wheels were available at Cochin only would possibly suggest that the

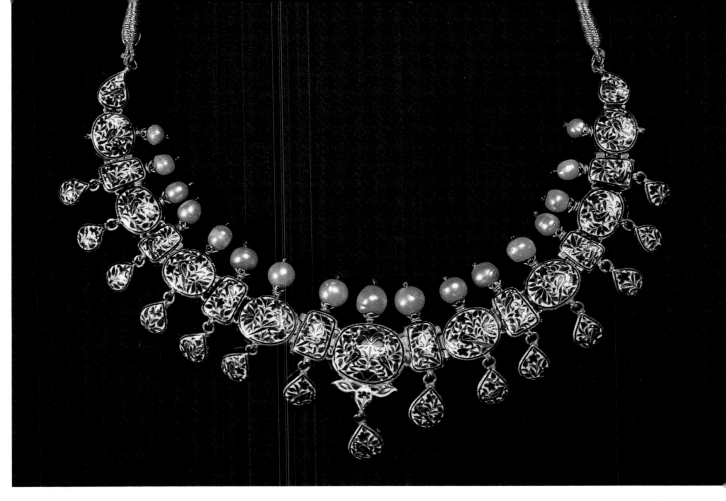

Necklace. *The enamelled reverse of a 'navratan'*
(nine gems) necklace.
Mughal period, eighteenth century AD.
Provenance unknown.
National Museum, New Delhi, 64.142

Finger-ring. *An enamelled gold ring studded*
with precious stones.
Mughal period, late seventeenth century AD.
Provenance unknown.
Salar Jung Museum, Hyderabad.

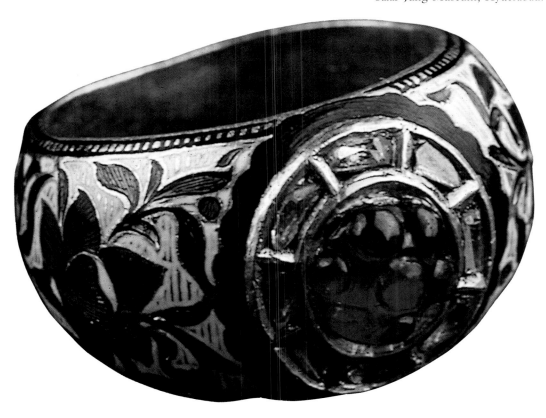

abrasive corundum mined, both in Salem and Coimbatore districts of Tamil Nadu was exported by sea to Surat in the seventeenth century AD.

Another French traveller, Thevenot, who visited the diamond mines in the Golkonda Kingdom in 1666 AD calls this stone white emery and states that it was called 'corind' in Telugu. It is from the word 'corind' that the English word, corundum appears to have been derived. The Germans called it 'korund'. Thevenot had also seen a similar saw in the Golconda kingdom, He remarks, 'they cut the sapphires with a bow of wire, whilst one workman handles the bow, another pours continually upon the stone very liquid solution of the powder of white Emrod, made in water; and so they easily compass their work. That white Emrod is found in stones, in a particular place of the Kingdom, and is called carind in the Telengy language. It is sold for a crown or two Rupees the pound and when they intend to use it, they beat it into a powder.' Yet, the diamonds were cut in a different manner. As Thevenot has mentioned it, 'When they would cut a diamond to take out some grain of sand, or other imperfection they find in it they saw it a little in a place where it is to be cut, and then laying it upon a hole that is in the piece of wood; they put a little wedge of iron upon the place that is sawed, and striking it as gently as may be, it cuts the Diamond through.'

Tavernier, on the other hand, observed in the seventeenth century that the Indian lapidary merely smoothened the rough edges of the gemstone, or cut it encabchon and that he did not attempt to cut symmetric facets for fear of reducing the weight of the gem. The statement of Bhartrahari, a Sanskrit poet, that the lapidaries did not hesitate to reduce the weight of a gem in order to bring out its brilliance, disapproves Tavernier's observation. In most of the cases, however, the precious stones were set in their original shape.

After the completion of enamelling, the hollow ornament was filled with shellac on which precious stones were set. The ornament was then sent to a different craftsman, *manikya-bandhaka* or the *kundansaz* who arranged for stone-setting. The grooves were initially made for the setting in the form of an artistic scroll. A piece of thin silver sheet, popularly known as *dak*, alloyed with three *ratis* (carats) of pure gold to a *tola*, was cut to shape, made concave and then highly polished. This was then fixed in each groove to give lustre to the stone. Upon it was placed the stone and then set. In case the colour of the stone was light, the *dak* was tinted with transparent colour. Sometimes, the back of the stone itself was given a tint called *joban*. The purest gold leaf was employed for this setting which was pressed well around the gems with a steel bit, forming an edge around them.

In fact *kundan*, the ancient name given to the purest variety of gold which is fully purified in fire, and the foils of it were set as the base to hold the gem firmly in its place. Later, the work itself was given the name of *kundan* work. In ancient jewellery sometimes colourful jade or crystal is found embedded in place of precious gems. In the costliest jewellery of the Mughal era, particularly of Aurangzeb's period and of the later Mughals, jade was used for making Islamic jewellery as gold was prohibited for Muslims in the Quran.

With the advent of the British in India, the gems came to be set with open claw technique which leaves the underside of a stone clear. The polishing was done keeping in view the original shape and colour of the stone. The chased surface of the ornament was rubbed with agate to produce a smooth and glittering surface.

Jewellery box. *'Kundan' (inlay) work with diamonds, a speciality of Jaipur. Mughal period, eighteenth century AD. Rajasthan.* National Museum, New Delhi, 89.1022.

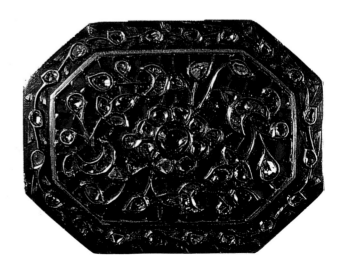

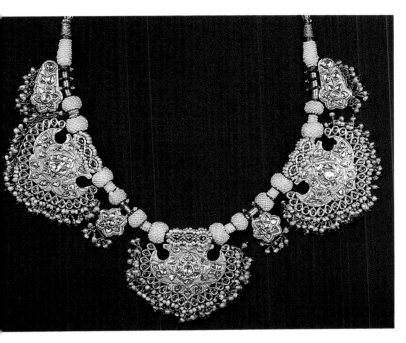

Necklace. *Pink, fan-shaped enamelled pendants studded with diamonds and skirted with pearl droplets.*
National Museum, New Delhi.

Above, right: *A representation of the deity of Srinathji in the temple of Nathdwara, Rajasthan. The figure is decked from head to toe in jewellery.*

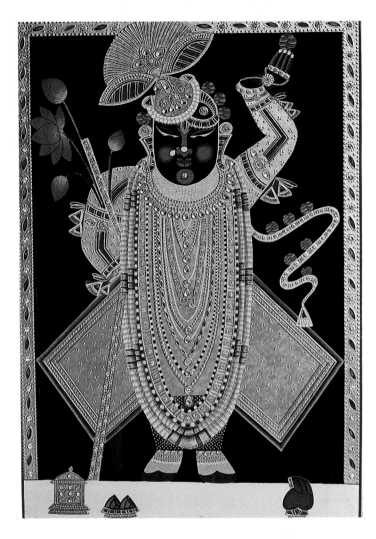

Necklace. *Part of the temple jewellery worn by the priests of the Srinathji temple at Nathdwara. Eighteenth century AD. Rajasthan.*
National Museum, New Delhi, 89.967.

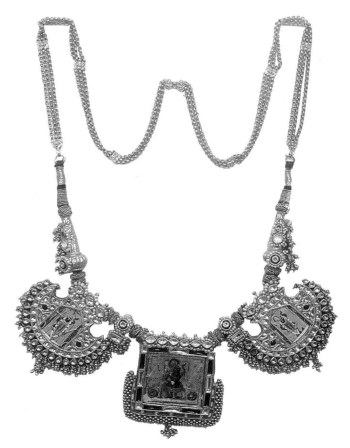

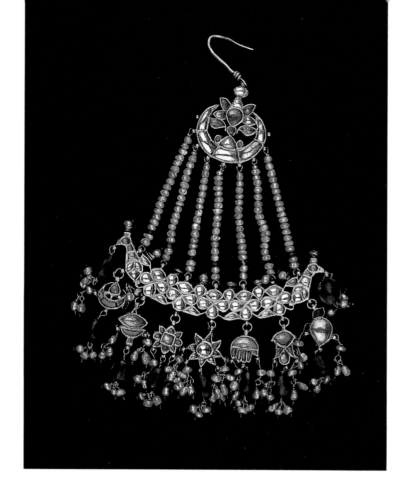

Headgear. *An enamelled gold 'jhumar' (head ornament) studded with stones. The reverse of another 'jhumar' with a dancing peacock is shown below. Twentieth century AD. Lucknow, U.P.*

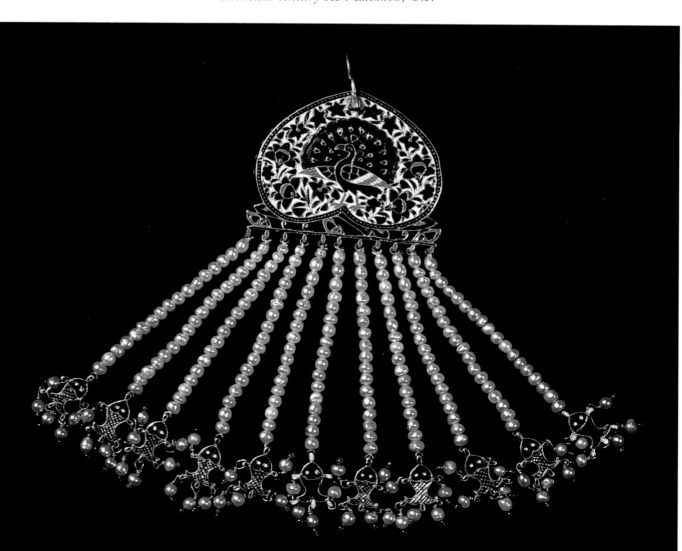

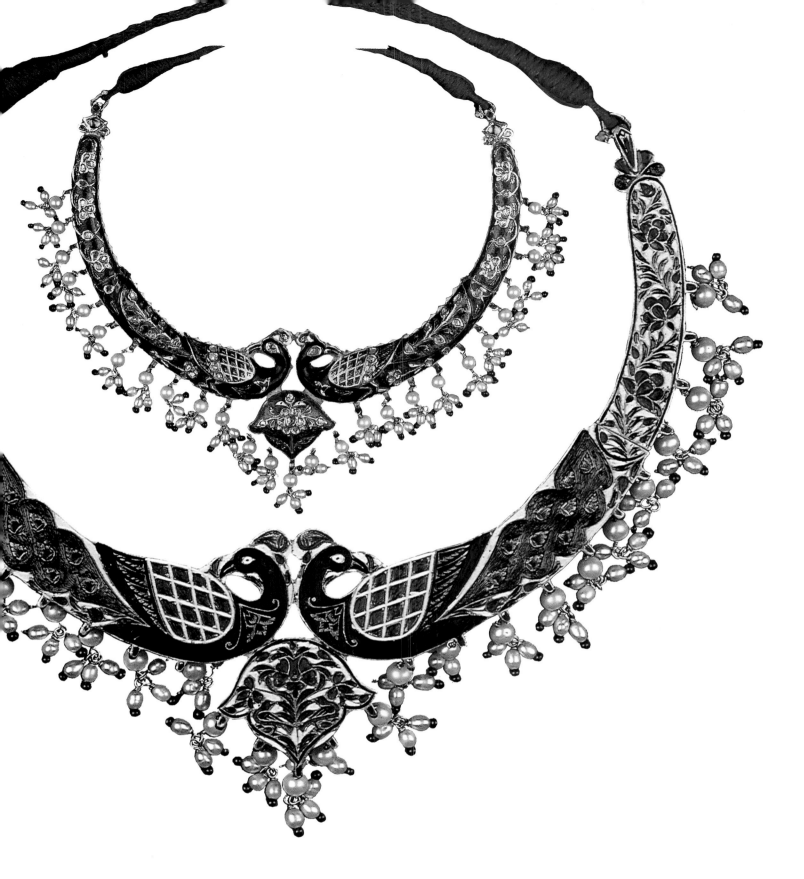

Gold necklace. *A 'hansuli' shaped like two peacocks,
with pearl droplets. The enamelled reverse
is shown in the outer circle.
Nineteenth century AD. Rajasthan.*

93

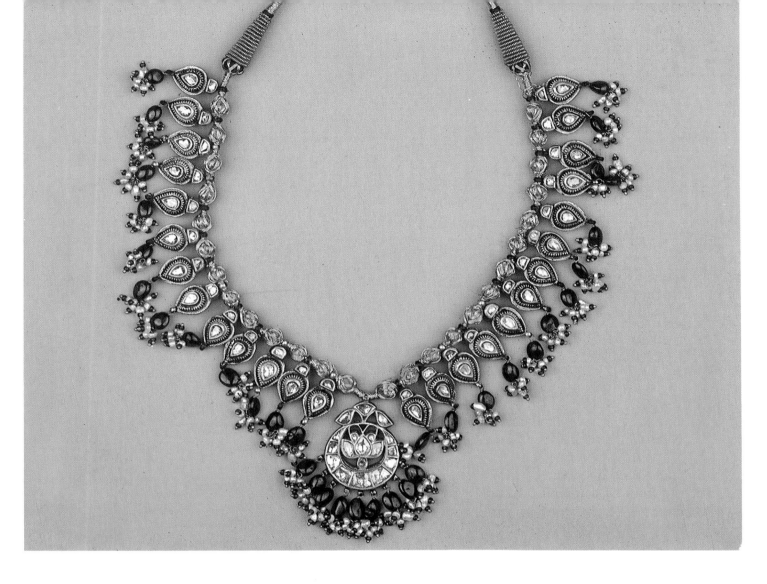

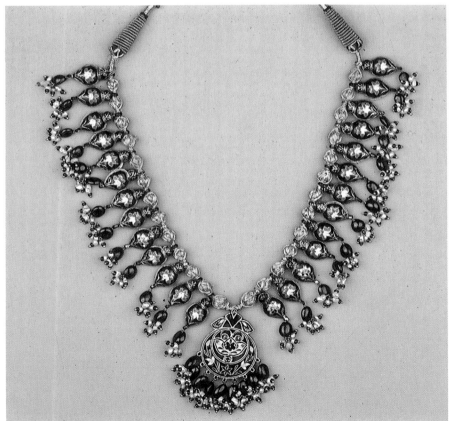

Gold necklace. *A 'champakali' (jasmine bud) necklace with pearls and precious stones. The enamelled reverse side is shown on the left.*
Nineteenth century AD. Delhi.

Archer's Thumb-Rings of the Mughal Era

An archer's thumb-ring, often inlaid with gold and silver wire and studded with precious and semi-precious stones, was not only used as an ornament but had its utilitarian value. A large number of thumb-rings, made of metal, ivory and precious and semi-precious stones, are today found in various national and international museums and other private collections.

The tradition of using the thumb-ring as an aid in achieving improved target accuracy and to cover greater distance for the flight of an arrow, seems to have first originated during the rule of the Han dynasty (206 BC - 220 AD) in China. The tradition was later adopted by the Mongols who finally brought it to Turkey, Persia and India.

From the utilitarian point of view, the high point at the front of a thumb-ring acts as a kind of hook for the smooth transition and for releasing the bow-string. It further protected the archer's thumb from the pressure and friction of the string as and when it was drawn and released.

The first known Mughal archer's thumb-ring, made of pale-white jade, belonged to Jahangir. It bears the legend 'Shah Saleem' which would suggest that it was fashioned for Saleem, (who later adopted the title of Jahangir) when he was still a prince (Shah) and had not ascended the Mughal throne. It is presently housed in the Bharat Kala Bhavan, Varanasi.

The other two well-known Mughal thumb-rings, bearing exactly the same legend and description, belonged to the Mughal emperor, Shah Jahan. The one, presently housed in the collection of the Salar Jung Museum, Hyderabad, is made of dark green nephrite and bears an inscription, 'Sahib-e-Qiran Saani' which means the Second Lord of the Auspicious Conjunction. The date given here is 1041 H, equivalent to 1631 AD. The other thumb-ring of the emperor Shah Jahan, having a similar legend, colour and form, is now preserved in the Victoria & Albert Museum, London. The date given here in Hijra year, however, is 1042, equivalent to 1632 AD.

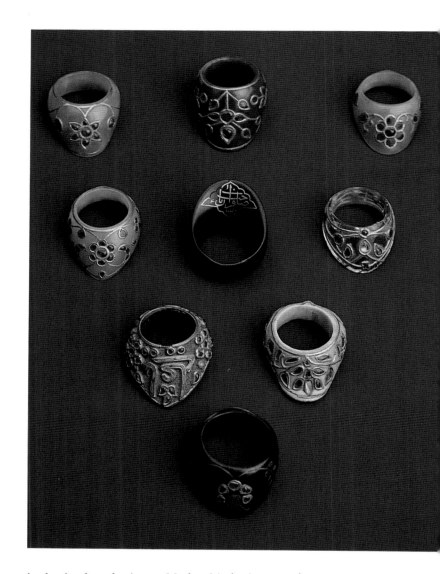

Archer's thumb-rings. *Made of jade, ivory and agate with gold inlay and studded with precious stones. Mughal period, seventeenth century AD. Provenance unknown.* Salar Jung Museum, Hyderabad.

Select Reading List

Aziz, A.	*Arms and Jewellery of the Indian Mughals*, Lahore, 1947.
Birdwood, George	*The Industrial Arts of India*, Reprinted, London, 1971.
Brij Bhushan, Jamila	*Indian Jewellery and Ornaments and Decorative Designs*, Taraporewala Sons & Co Ltd, Bombay, 1955.
Chandra, Rai Govind	*Indo-Greek Jewellery*, New Delhi, 1979.
Devasahayam, N.	'Roman Jewellery from Vellalore Site During the Sangam Period', *Lalit Kala, No. 21*, Lalit Kala Akademi, Bombay, Plate XIV, Figs. 1-7.
Elurin, Verrier	*The Art of the North-East Frontier*, Shillong, 1959.
Fazl, Abul	*Ain-i-Akbari*, translated by H. Blochmann, 3rd edition, New Delhi, 1977.
Finot, Louis	*Les Lapidaires Indiens*, Paris, 1896.
Hendley, T.H.	'Indian Jewellery', *Journal of Indian Art and Industry*, Vol. XII, Nos. 95-107, London, from 1906 to 1909.
Hendley, T.H.	*Indian Jewellery*, London, 1909.
Jacob, S.S. and Hendley, T.H.	*Jeypore Enamels*, London, 1886.
R.P. Kangla, (ed.)	*Kautilya's Arthasastra*, Bombay, 1963.
Kazim, M. (ed.)	*Alamgir Namah*, Asiatic Society of Bengal, Calcutta, 1868.
Krishnadasa, Rai	'The Pink Enamelling of Banaras', *Chhavi*, Golden Jubilee Volume, Vol. I, Bharat Kala Bhavan, Banaras, 1971.
Markel, S.	'Jades, Jewels and Objets d'Art', *Romance of Taj Mahal*, (ed. P. Pal), Los Angeles County Museum of Art, 1989.
Marshall, John	*Mohenjodaro and the Indus Civilisation*, 3 vols. London, 1931.
Marshall, John	*Taxila*, 3 vols. Cambridge, 1951.
Morley, G.	'On Applied Arts of India in Bharat Kala Bhavan', *Chhavi*, Golden Jubilee Volume, Banaras, 1971.
Mukherjee, T.N.	*Art Manufacturers of India*, Glasgow, 1888.
Nagaswamy, R.	'Temple Jewellery', *Decorative Arts of India*, (ed. M.L. Nigam), Salar Jung Museum, Hyderabad, 1987.
Nigam, M.L.	'Jewellery—Inlay Work and Studding of Gems', *History of Technology in India*, Vol. I, Indian National Science Academy, New Delhi, 1997.
Nandagopal, Choodamani	'The Traditional Jewellery of Karnataka', *Decorative Arts of India* (ed. M.L. Nigam), S.J.M., Hyderabad, 1987.
Nandagopal, Choodamani	*Temple Treasurers*, Vol. II, Temple Jewellery, Craft Council of Karnatak, Banglore, 1997.
Sarma, S.R.	'Historical Notices on Gem Cutting in India', *History of Science and Technology in India*, Vol. VI, Sundeep Prakashan, Delhi, 1990.
Sekhar, A.C.	'Filigree Industry of Karimnagar', *Census of India*, Vol. II, Part VII A (I), 1961.
Shastri, A.M.	'Gems in the Gupta Age', *Decorative Arts of India,* (ed. M.L. Nigam), Salar Jung Museum, Hyderabad, 1987.
Skelton, Robert (ed.)	'Arts of the Goldsmith,' *The Indian Heritage: Court Life and Arts Under Mughal Rule*, Victoria & Albert Museum, London, 1982.
Untracht, Oppi	*Traditional Jewellery of India*, Thames and Hudson, London, 1997.
Watt, G.	*Indian Art at Delhi*, Calcutta, 1903.
Warmington, E.H.	*Commerce Between the Roman Empire and India*, Cambridge, 1928.